IMAGES
of America

BELLINGHAM

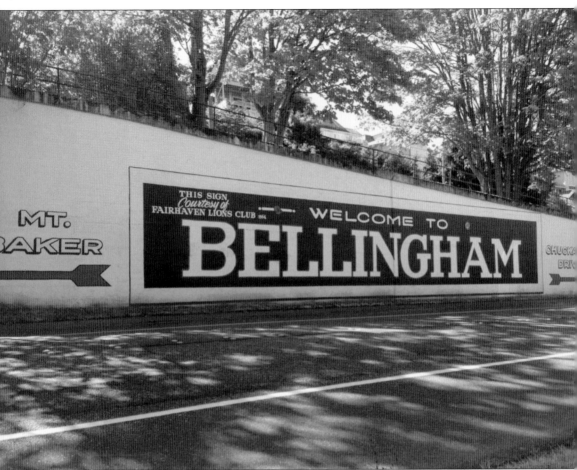

With a rich history full of dreams, adventure, heartbreak, and perseverance, the "City of Subdued Excitement" has come out on top and refuses to lose heart. With a sense of responsibility for the environment and a sharing connection among neighbors being commonplace, there is no wonder why Bellingham has been considered numerous times as a model community. (Author's collection.)

ON THE COVER: June 3, 1930, was the day the circus came to town. Surrounded by excitement, the Bellingham community took to the streets to watch as Al G. Barnes Circus made its stop for the first time in history. In the distance, one can see the band crossing the road at the bottom of the hill as onlookers watch from all around. (Courtesy of the Whatcom Museum.)

IMAGES
of America

BELLINGHAM

Cecil W. Jentges

ARCADIA
PUBLISHING

Published by Arcadia Publishing
Charleston, South Carolina

Printed in the United States of America

Library of Congress Control Number: 2014944691

For all general information, please contact Arcadia Publishing:
Telephone 843-853-2070
Fax 843-853-0044
E-mail sales@arcadiapublishing.com
For customer service and orders:
Toll-Free 1-888-313-2665

Visit us on the Internet at www.arcadiapublishing.com

To my mother, Kathy Jentges, who taught me selflessness, discipline, and the importance of family. And to Elizabeth Maddax to commemorate March 27, 2014, just before 3:00 p.m.

CONTENTS

ACKNOWLEDGMENTS

I would like to acknowledge Jeff Jewell and the Whatcom Museum for their support and providing valuable insight on the history of Bellingham. I also want to give a special thanks to Gordy Tweit; without his nostalgic insight, knowledge of history, and photograph collection, this book would not have been possible. I also would like to thank Rebecca Coffey, my editor at Arcadia Publishing, for her patience and keeping me focused.

Unless otherwise noted, all photographs are from the Gordy Tweit collection.

INTRODUCTION

Bellingham's history was molded in the hands of dreamers, on the backs of the fortune-seekers, and in the heart of adventurers. Guided by the kindness of the area's first inhabitants, the Lummi tribe, as well as the surrounding Samish, Nooksack, Semiahmoo, and Skagit tribes, Bellingham Bay was able to come together and become Washington State's secret masterpiece of the north.

Bellingham's story starts with a quest to find Marco Polo's mystical land of Cathay (China), or more specifically, the legendary Strait of Anián. Over 200 years later, these stories still influenced many explorations leading to the discovery of the Americas, and in 1592, Juan de Fuca came up the West Coast from California still seeking the Strait of Anián. When he arrived at Victoria Island, he believed he had found the strait, but this was later discovered to be wrong. Still, his efforts were not without reward, and the strait he discovered was later named after him. It was not until 200 years later that the first Europeans entered the strait and the bay in 1791. Spanish explorer Manuel Quimper sent a sloop into the Strait of San Juan de Fuca and discovered Mount Baker. He named it La Gran Montana del Carmelo. Not long after, Francisco de Eliza, who served under him, entered Bellingham Bay. He named the bay Bahia de Gaston. However, after the Spanish-British Nootka Conventions in the 1790s, Spain's exclusive ownership of the area ended and Russia, England, and the United States started making their own claims. George Vancouver entered the area while on his own exploration in 1792, and he renamed many of the areas landmarks, including Bellingham Bay for Sir William Bellingham, Vancouver's British Navy provisioner. After the War of 1812, the 49th parallel (US-Canadian border) was established with joint occupation, and in 1824, Russia signed an agreement that it had no claims to the area. It was not until June 15, 1846, that Britain ceded completely to its side of the border. In 1853, the Washington Territory was formed.

Even before Washington was its own territory, Bellingham was already in the beginning stages of becoming established. In 1849, while trading with the Lummi natives, Samuel Hancock was told that they had seen coal in Bellingham Bay, but he was forbidden to mine it. In 1852, Capt. William R. Pattle could be found in the San Juan Islands working on cutting and delivering lumber for San Francisco to help rebuild it after the fire. While working, he received word from different local natives that there was coal in Bellingham Bay. Pattle investigated and found that there was indeed coal. He established his claim, which would become the Unionville settlement and later become the towns of Bellingham and Fairhaven. He headed back to San Francisco to get some companions to help him set up claims, but at the same time, down in Olympia, Capt. Henry Roeder and Russell V. Peabody were speaking to Lummi chief Chow'it'sut about a water source they called "what-coom," meaning "noisy rumbling water," that was ideal for the waterpower they needed for a mill. They decided to hire a few Lummi Indian guides and entered Bellingham Bay by canoe on December 14, 1852. After a little searching, they found Whatcom Creek and struck their claim in what would become the town of Whatcom. They then returned to Olympia to pick up a Mr. Brown, who was a millwright, and went down to San Francisco to get the machinery and

supplies necessary to start the mill. Upon their return, Captain Pattle, as well as a Mr. Morgan and a Mr. Thomas, were already located on their claims, thus making them the first Europeans to settle in the area. As time progressed, more and more people came to the area to work the coal mine and lumber mill as well stake their own claims. In the summer of 1853, in an area of land owned by Roeder and Peabody, an uprooted tree exposed a vein of coal. This led to an examination of the area that became the Bellingham Coal mine. It was purchased by Captain Fauntleroy and associates to add to their property just north of the discovery, which would later become the start of the town of Sehome. Two years later in December 1855, under the donation law, 18 people laid claim to Whatcom County, even though there were many other people living in the area at the time. In the same year, the Indian War broke out in the Northwest, creating the need to establish Fort Bellingham. Aside from an issue with the natives from Vancouver, it was relatively peaceful. There were still conflicts over landownership of the San Juan Islands, creating tension between the British and the United States. After the Pig War confrontation in 1859, the troops in Fort Bellingham were ordered to relocate to the San Juan Islands.

During this time, the Gold Rush hit the area, especially in 1858. During three to four months at the height of the Gold Rush, there were more people in Whatcom County than all the surrounding territories put together, encouraging the belief that it would be the "San Francisco of the North." However, this boom was short lived; once it was required for the gold-miners to receive a permit from Vancouver before they could mine, they logically circumvented Bellingham Bay.

The next great venture for Bellingham was its rail system, the connection between Portland, Oregon, and Canada. It was unknown whether it would be the terminus to cross the mountains or Seattle. Upon signing the agreement, it was voted in that Bellingham Bay would be that point, and business in the area boomed in anticipation. But this dream would end in heartbreak. When the map of the proposed route was presented to the secretary of the interior, he refused to accept it, stating it was against public interests to have the line go past Seattle before crossing the mountains. This caused a decline of the Bellingham area until the connection of the Northern Pacific made it through Bellingham Bay in 1883, spiking yet another anticipated boom. This boom was not quite as fast as expected due to other issues with the Kansas Colony, which ended with the town of Sehome merging with Whatcom to become the town of New Whatcom. This is around the time Nelson Bennett came up from Tacoma, Washington. Bennett's ability to convince a number of investors of the value of the town of Fairhaven was key to Bellingham emerging from its economic slump. Together with C.X. Larrabee, C.W. Waldron, E.L. Cowgill, and others, the Fairhaven Township and some of the companies of Whatcom were purchased from the landowners, notably Daniel Harris. The Fairhaven Land Company hired John Joseph Donovan as their chief engineer. This decision, backed by their financial power, forever shaped Bellingham, ending in the merging of the towns and the official incorporation of Bellingham as a city on November 4, 1903.

This book is a part of the Images of America series, and what better image to symbolize America than Bellingham, Washington? Its story starts with the friendly guidance of its natives and the merging of settlements from the pure tenacious grit of its first settlers, to continued growth, no matter what may come. Bellingham has experienced the ebb and flow of both joy and sorrow with its various industries, and its dreams have sailed high on its ocean waters as well as crashed against its shore. Yet here it stands. The images that follow this introduction capture the life of Bellingham, the industries that employed so many, and the sense of community that has survived through the years.

I feel that what directed the hearts of those that have made Bellingham what it is today was a mind-set that can best be described in the words of Mark Twain, one of Bellingham's most famous visitors: "Twenty years from now you will be more disappointed by the things that you didn't do than by the ones you did do. So throw off the bowlines. Sail away from the safe harbor. Catch the trade winds in your sails. Explore. Dream. Discover."

One

FIRST INHABITANTS
AND EXPLORATION

The Bellingham area was the home to Native Americans long before its discovery by either Europe or Russia and was known by its landmark "what-coom," later to be named Whatcom Creek. Though the area was already mapped and named by both Spanish and English explorers, it was not until the early 18th century that the first nonnative inhabitants started taking root. After Simon Fraser with the North West Company made it to the Strait of Georgia on August 6, 1808, the area became attractive for fur trappers and traders. Whatcom County's first recorded trading post was one of Hudson's Bay Company and established in 1825, only 3 years after its merger with the North West Company. It was not until 24 years later that an event 900 miles away would change its history forever: the great San Francisco fire of 1849.

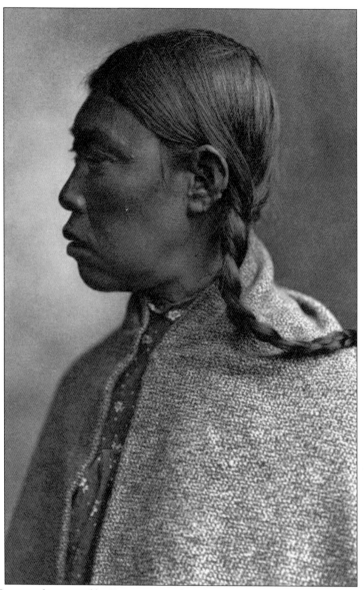

Bellingham Bay was discovered by European settlers; however, long before recorded history, there have been natives living in the area. The surrounding area was made up of four main tribes: Nooksack, Semiahmoo, Samish, and Lummi. Lummi tribesman first informed Capt. William R. Pattle of the coal that Bellingham Bay possessed, and then others guided Capt. Henry Roeder and Russell V. Peabody to Whatcom Creek for their sawmill. In 1855, the Indian Wars started in the Washington Territory, but the Bellingham natives, for the most part, stayed friendly. Due to being so close to Vancouver Island and the 49th parallel, British governor James Douglas was understood to be in charge of relations with the natives. As chief factor of the Hudson's Bay Company, he had extensive relations with the natives before it became an American territory, and he believed that it was cheaper to feed them than to fight them. He established reservations where the natives were given rations and access to the pony express. It is without saying that if the local tribesmen had not been so friendly, Bellingham would not be what it is today. (Courtesy of the Edward S. Curtis collection.)

Passed over by explorers as far back as 1587 by Juan de Fuca in his search for the Strait of Anián, it was not until 1791, Spanish Peruvian explorer Manuel Quimper's expedition, that a sloop was sent into the Strait of San Juan de Fuca and discovered Mount Baker. Quimper named it La Gran Montana del Carmelo. Not long after, he sent Lt. Francisco de Eliza, who served under him, into Bellingham Bay. His men set up an encampment by the mouth of present-day Padden Creek, but they were not able to stay for long. Hostile Lummi tribesmen drove them back to their rowboats. He named the bay Gulf de Gaston, but the following year, the British under George Vancouver's command renamed it. It has been recorded that in the late 19th century, a Spanish goblet and musket were unearthed, though they were not confirmed to have been from Manuel Quimper's crew. (Author's collection.)

Soon after Charles Barkley's expedition in 1787 that lead him to the Juan de Fuca Strait, George Vancouver came to the San Juan Islands. As a captain in the British Royal Navy, Vancouver is responsible for the naming and renaming of many cities and landmarks all along the Pacific Northwest. Some of the most notable ones for the Bellingham area are Mount Baker, which was named after the sailor who spotted it, and Bellingham itself, named after Sir William Bellingham, Vancouver's British Navy provisioner. Vancouver entered the area in June 1792, just as the Spanish-British Nootka Conventions started, seizing the opportunity to lay claim to territory that up until then was claimed by Spain before Russia or the United States. His orders were to survey every inlet and outlet along the west coast, often with small sail or rowboats, an expedition he did not finish until September 1795. (Both, author's collection.)

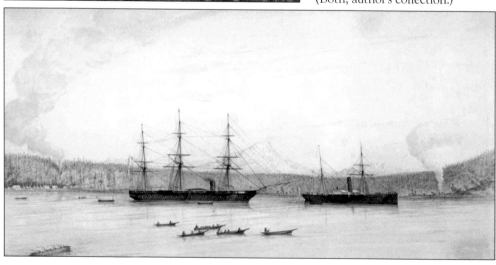

Two

THOSE WHO PAVED THE WAY

There is no way a person could lay down enough pages or images that could do justice to all those who have sacrificed and molded the great city that is Bellingham. Bellingham rests on the shoulders of the bold, the aspirations of its dreamers, and the lifetimes of hard work. All sacrificed to create what Bellingham residents enjoy today and to pass the baton of innovation to the next generation. Though this text hardly scratches the surface of the countless pioneers, the individuals shown are great examples of the caliber of heart and the stroke of genius that so many of them possessed.

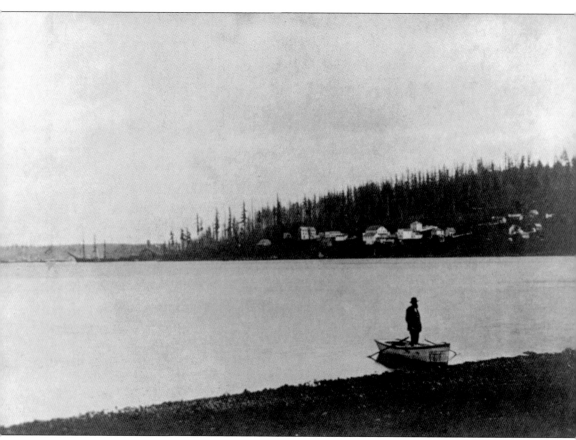

One of the original 16 to take advantage of Whatcom County's donation law, established in 1855, Daniel Jefferson "Dirty Dan" Harris, at 22 years old, claimed 160 acres of land that, per Edward Eldridge, was originally settled on by M. Thomas, one of the three original settlers of Bellingham. In 1883, this piece of land would grow from what was barely a gathering of houses into the township of Fairhaven. Just before the late 1800s, Nelson Bennett arrived in the area, and through his company, he purchased the land from Daniel Harris for roughly $70,000. This decision changed Bellingham's fate forever. Harris has become somewhat of a historical icon for the Fairhaven district of Bellingham, with a restaurant named after him as well as statue constructed in his likeness. To this day, there is an annual celebration called Dirty Dan Days that occurs every spring.

John Joseph Donovan, the maker of empires, moved to Fairhaven in 1888. At the time, Fairhaven was a grouping of homes in the woods with maybe 50 inhabitants. With the financial backing of the Fairhaven Land Company, Donovan's mind and hard work as their chief engineer created a railroad; coal mines on the Skagit River were opened, and Fairhaven was organized into a city with public improvements. Once Fairhaven was organized, Donovan focused his efforts on railway projects, specifically to help connect the Bay area with Canada, Portland, and over the Cascades to Spokane. During this time, Donovan opened a lumber and logging company with J.H. Bloedel and the Larson estate, providing jobs for 600 men. Later, he was involved as the director of First National Bank, director of St. Joseph's Hospital, which was secured largely because of his efforts, trustee at the State Normal School, and a member of the chamber of commerce, with the merging of Fairhaven and Whatcom largely due to his influence.

In 1888, Harris sold his property to Edgar L. Cowgill, I.M Wilson, and Nelson Bennett, which they used to establish the Fairhaven Land Company with C.X. Larrabee. Cowgill, a businessman, played an integral part in the development of Bellingham. After starting the Fairhaven Land Company, Cowgill worked side by side with Bennett, running Bellingham Bay Land Company under Edward Eldridge. Cowgill also began Skagit Coal & Transportation with many members of the Fairhaven Land Co., Fairhaven & Southern Railroad, and was the vice president of Homan Lumber Co. Cowgill married Lillie Anna Wasmer on November 26, 1889, and in the following year, he had a home built off of Thirteenth and Harris Streets in Fairhaven. Later in life, he moved to 723 Fourteenth Street. There is an avenue named in his honor that runs east-west intermittently from Fourth to Thirty-eighth Street.

Arriving in Bellingham in 1890, Charles Larrabee was already a successful businessman. Having made a small fortune in Montana before moving to Portland, Oregon, Larrabee became acquainted with Nelson Bennett (founder of Tacoma, Washington), and together, they recruited other businessmen to form the Fairhaven Land Company to purchase the town of Fairhaven from Daniel Harris, later to become a district of Bellingham. Larrabee later purchased Bennett's holdings and retained control of the company until his death. Between developing the land, founding Citizens Bank of Bellingham, and organizing the Roslyn-Cascade Coal Company, it is well established that Larrabee is greatly responsible for the development of beautiful Bellingham. After his death, his family donated 20 acres to create a state park named after him. Larrabee State Park is the first state park in Washington's history, and it was arranged that if the land were to be used for any other reason, it would be returned to the Larrabee family.

E.B. Deming and his brother Frank first became involved in the Bellingham area in 1899, when they purchased Franco-American North Pacific Packing Company from Count Roland Onffroy. After purchasing another cannery in Anacortes and organizing it into Pacific American Fisheries (PAF), they also proceeded to purchase Eliza Island in Bellingham Bay. This island ended up being used as a shipyard. In 1900, Deming moved to Bellingham to manage the company and focus on expansion. Over the next few decades, Deming as president increasingly expanded PAF, including property in Alaska. PAF would go on to be one of the largest exporters of canned salmon in the world and dramatically helped support Bellingham's economy. To continue expansion and growth, the Deming family made the company public in 1928. In 1934, Deming sold his controlling shares, marking the end of the Deming family involvement.

Three

A Tale of Four Towns

Ella Higginson once said, "I have lived in four towns without even having to move," a perfect insight to the fast progression Bellingham underwent and the understanding between four separate towns of what needed to be done to survive. All four had many things to offer: Sehome's coal, Whatcom's courthouse, Bellingham's hospital, and Fairhaven's fisheries and shipyards. All played vital parts that when combined, allowed Bellingham to excel.

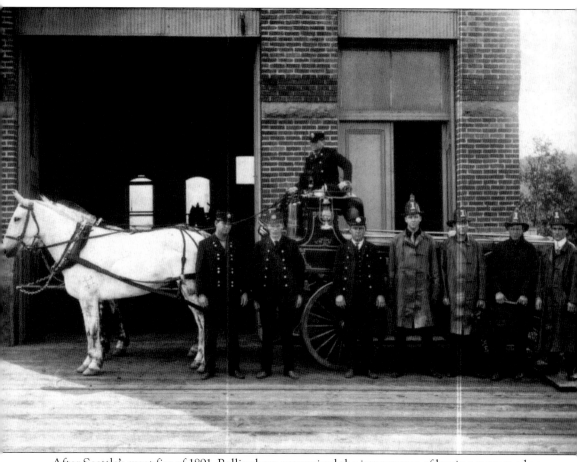

After Seattle's great fire of 1891, Bellingham recognized the importance of having more modern equipment than just leather buckets for their bucket brigades. Both Hook and Ladder Company, established in 1889, and hose companies started shaping the industry. A great example is this early 20th century fire department wagon that belonged to Fairhaven; it had a pump and running boards to transport the firefighters. Up until this point, firefighters would have to run to the fire, often too winded upon arrival, to immediately work on putting the fire out. By 1904, the Hook and Ladder Company and the Sehome Hose Co. were unified until disbanded due to the establishment of the City of Bellingham Fire Department. This would be the first year the city took charge and created two fire stations.

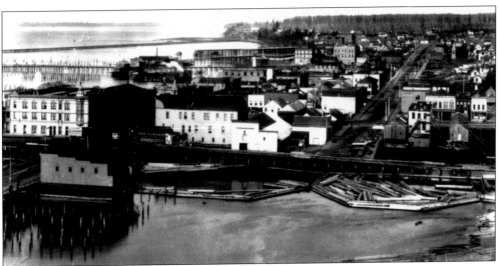

The coal industry was the first major industry to contribute to the growth of what is now Bellingham. The coal bunkers seen here created a township, and the workers' settlement became the town of Sehome before it merged with Whatcom to form New Whatcom.

It is difficult to imagine this sparsely populated view from Taylor Avenue as the future home of the Sehome cannery, which later became a part of Pacific American Fisheries.

Four=Leaf Clover

I know a place where the sun is like gold,
* And the cherry blooms burst with snow,*
And down underneath is the loveliest nook
* Where the four-leaf clovers grow.*

One leaf is for hope, and one is for faith,
* And one is for love, you know,*
And God put another in for luck—

Ella Higginson was a writer, poet, and community leader. In 1889, she wrote her first article to achieve national acclaim, due to its sensitive topic—divorce. The following year, she wrote her most famous poem, "Four Leaf Clover," as shown here both as a poem and put to music. While writing, she helped establish Bellingham's first public library. After her husband passed, she became the campaign manager for Frances C. Axtell, who went on to be elected as the first female member of the Washington State House of Representatives, in 1912. Higginson was a talented writer and became the poet laureate of Washington in 1931. Living in Bellingham during its merging, she was often quoted saying she "lived in four different towns without even moving."

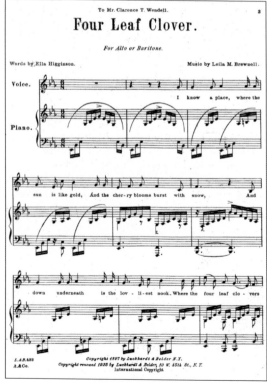

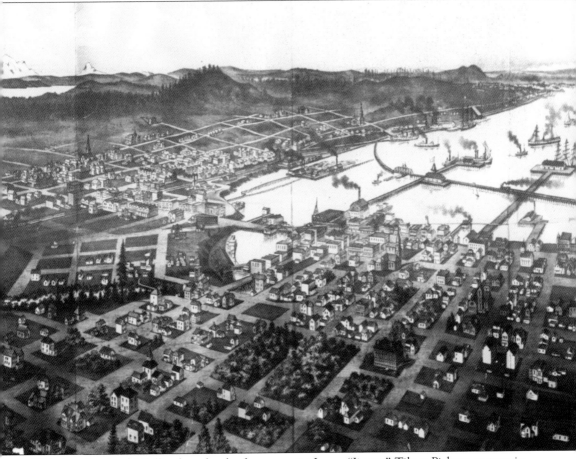

This is a drawing of Bellingham by the famous artist James "Jimmy" Tilton Pickett, as seen in the newspaper *Reveille*. The image, clearly seen from the perspective of an artist, exaggerates Bellingham's prosperity, focusing more detail on the center and the ships, giving an impression of Bellingham having an ambitious industry. Also worth noting is the detail placed in the street layout of Bellingham and the topography. The *Reveille* was a local newspaper that was only in publication from 1888 to around 1898, though Jimmy Pickett became known as a newspaper artist for some of the big papers, including Seattle's *Post Intelligencer* and Portland's *Oregonian*. Jimmy was a half-native son of Capt. George Pickett, who, even as a young child, showed signs of being artistically gifted. Jimmy died on August 28, 1889, at the young age of 31, due to the combination of typhoid and tuberculosis.

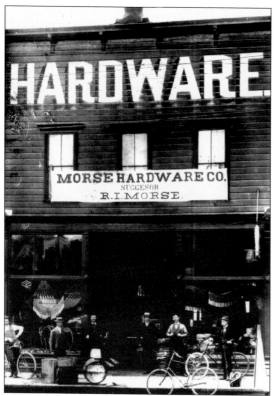

In 1884, Robert I. Morse opened his store in Sehome with $3,000 worth of paints, oils, wallpaper, and guns with his partner D.R. Caldwell, whom he later bought out. Morse had hoped that the Great Northern Railroad would choose Fairhaven as its western headquarters and terminus. Morse Hardware had a store until 1982, which is now occupied by Morse Distribution Inc. and Industrial Supply.

John W Roscoe was the sole proprietor of the Casino Theatre off of Eleventh Street between Harris and McKenzie Avenues. Sailors or lumbermen would frequent the Casino Theatre, the Vineyard Club next door, or the Spokane Hotel nearby for all the adult entertainment and lodging they might need.

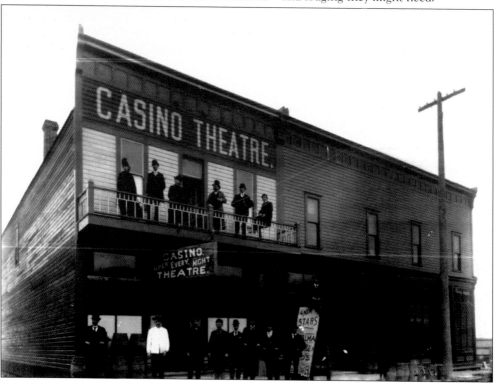

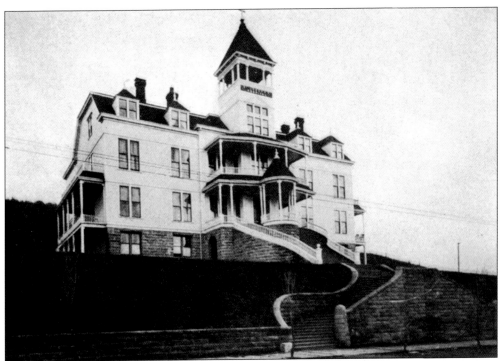

Once upon a time, the Bellingham area had two hospitals serving the area. In 1891, St Joseph's was started by Sr. Theresa Moran and Sr. Stanislaus Tighe, who traveled across the country to Fairhaven from Sisters of St. Joseph of Peace in New Jersey. Around the same time, St Luke's Hospital was being established on the corner of Forest and Holly Streets by St. Paul's Episcopal Parish. In the 1930s, St. Luke's Hospital was incorporated as a nonprofit community hospital, and in 1989, it merged with St. Joseph's Hospital after being acquired. Currently, St Joseph's is located at 2901 Squalicum Parkway.

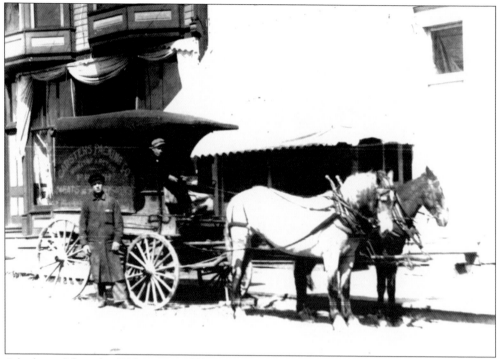

A look into life in the 1920s, one would be sure to see Carsten's Packing Company wagon around as seen here just outside the Monahan Building in the Fairhaven district. The wagon was positioned just outside Fairhaven Pharmacy, which was owned by George Finnegan at the time.

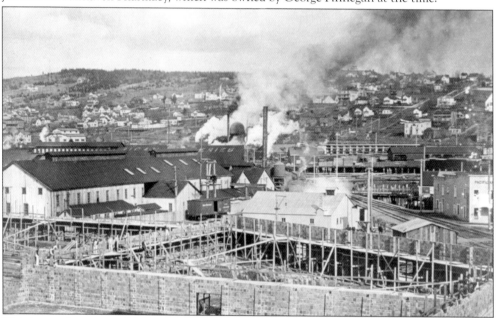

This is a perfect image of Bellingham in the 1930s, capturing the essence of growth. Bellingham, already unrecognizable to the 1900 version of itself, prospered from World War I. Shown here is the Puget Sound Mill's domed incinerator hard at work, with railway running through, all silhouetted by the housing developments in the surrounding hills.

Four

BUILD AND THEY WILL COME

From the beginning of rumors about coal in Bellingham Bay to the current berry farms, tourism, and refined oil from surrounding areas, Bellingham is a seasoned city to the roller coaster of economic ups and downs. A debt of gratitude is owed to many local industries that shaped this great city, to both those that are still standing and those that are no longer in existence today.

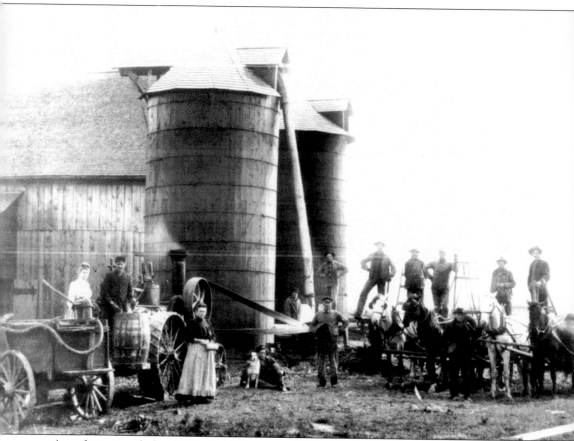

A perfect view of what life looked like out on the farm during the early 1800s, agriculture, like many other industries, was being redefined by the introduction of machinery, slowly replacing the use of horses. This caused many types of crops to flourish, particularly "tulipmania" in the near future.

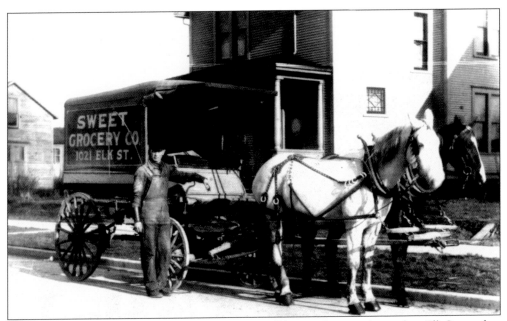

In the 1890s, the Sweet Grocery Company was a well-known business located on Elk Street that provided food and household goods to the locals during a time of change. It was common to use horse-drawn carriages to pick up and deliver product.

Horses were often used by the Bellingham Bay Logging Company to move not only freshly cut lumber, but also finished product. Pictured here is Jake Kruzer with a load of wooden shingle bolts ready to be transported. Wooden shingle bolts were commonly produced by the logging company.

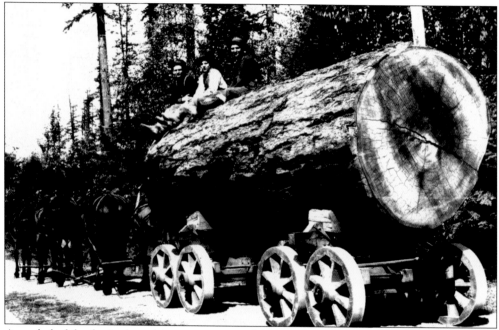

A symbol of the fortitude and ingenuity required during the pioneering of the Bellingham area, these three loggers sit on top of an extremely large log that was placed on a wagon with no assistance from modern technology. It is set up to be pulled by six horses, which was commonplace in the 1890s.

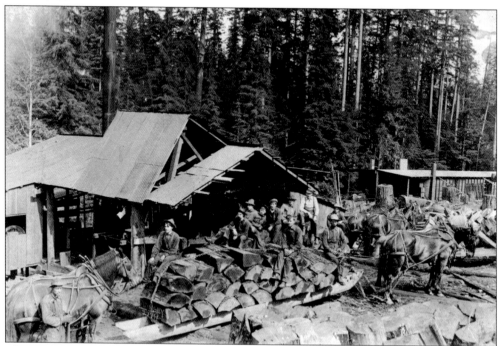

This is one of the many famous photographs taken by Darius Kinsey showing some of the day-to-day tasks involved in a life of working in the timber industry. In this image, Julius Moldren and his fellow lumbermen pose by their workhorses.

Pictured here is an example of what some of the virgin forests that made up the Bellingham area looked like. Posed below these majestic giants is a logging crew, with one member in the back standing on a springboard. Simply planks inserted into notches cut out of the tree, these springboards were effective tools to vary the height the loggers wanted to cut the tree.

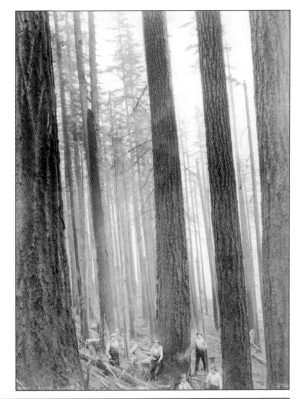

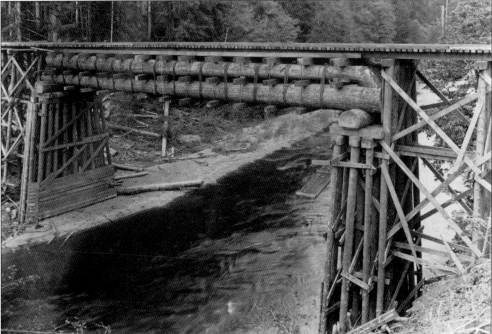

An example of a quickly made bridge built by one of the logging companies for their spur rail, these bridges were often abandoned after use. It is said that remnants of these structures may be found in the woods east of Bellingham.

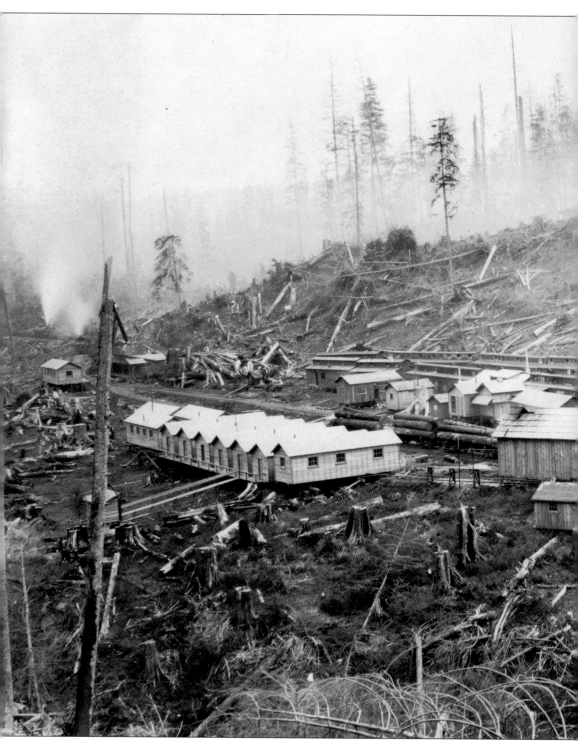

Logging camps were the forefront of operations. Quickly built, their purpose was to house the crews until the area was clear cut and loaded onto the railcars. These crews worked 10 or more hours per day to try and keep up with the demand, clear cutting down the old growth landscape at an

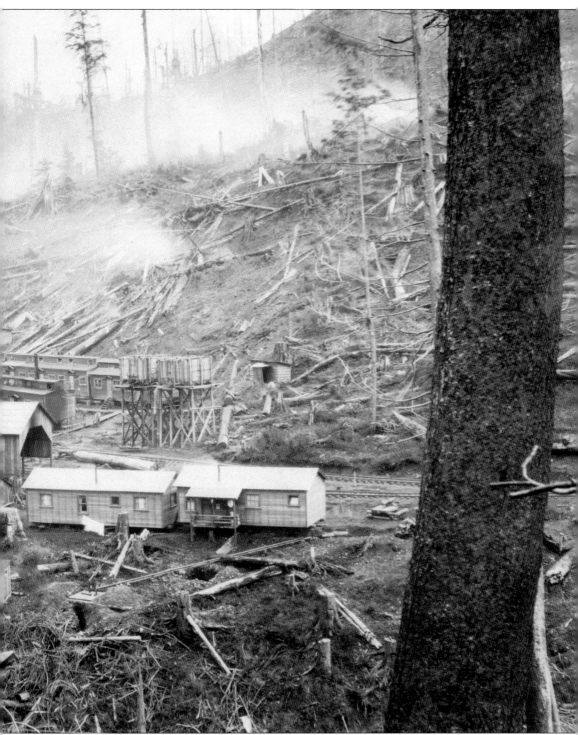

incredible pace. The lumber industry played a key role in Bellingham's development, first by clearing out a place to start its township, then by supplying work for its settlers, all the way to trailblazing paths to access Mount Baker, a major tourist attraction even in the early 20th century.

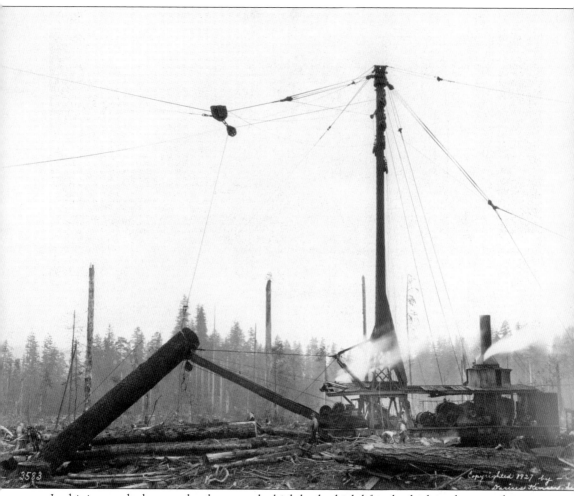

In this image, the latest technology was the high lead, which lifts a log high in the air and swings it aboard a logging train with much ease. The utilization of railroads in the 1890s forever changed the industry, and a company's success rate was heavily determined on whether a spur rail could be built near the job site. To the left of the spar, one can see a steam donkey, a common tool of the trade easily distinguished by the steam it emitted. Using the latest logging equipment of its time, the Bloedel & Donovan lumber mill quickly became one of the major mills of Bellingham. At the location of their first mill, J.J. Donovan donated the land to make a city park that to this day is called the Bloedel Donovan Park.

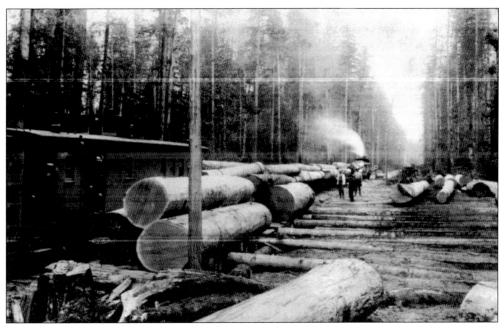

Toward the end of the 19th century, railroads were introduced to the logging industry, causing business to boom. Many logging companies built their own railways branched off of the mainline. This photograph is an example of one of these spur rails.

Darius Kinsey was famous for his photography of western Washington's old growth trees, loggers, and the lumber industry. In 1896, Kinsey married Tabitha Pritts, and they worked together for the rest of their lives. This is a photograph taken by Tabitha of Darius inside a tree with a Franklin car, illustrating just how massive the surrounding forest was.

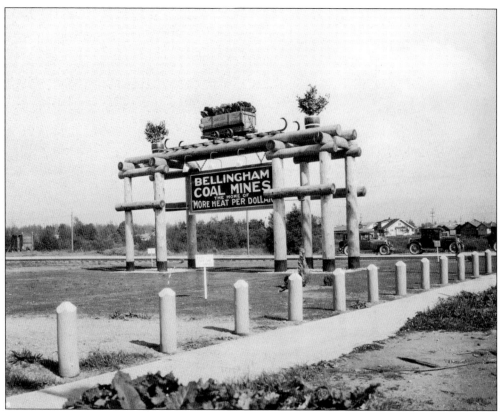

Located just north of Bellingham, off of Northwest Avenue, one could find the home of Bellingham Coal Mine Co. One of the industrial giants, this sign marked its entryway to the many that were employed here. The mine remained in operation up until the 1950s.

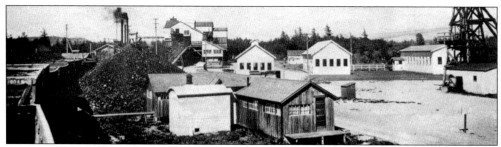

By 1922, the Bellingham Coal Mines' plant was the greatest producer of coal in the entire Northwest and provided the Bellingham area its largest individual payroll. Unlike other mines, this was due largely to it having two incline shafts for operation.

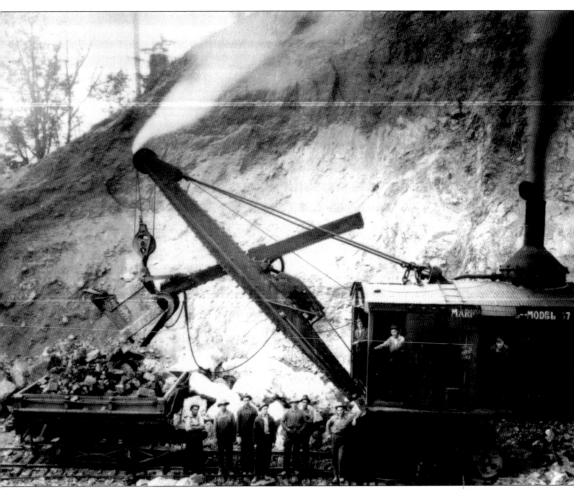

Ever since Captain Pattle was informed of coal being in Bellingham Bay in 1852, coal has been a major industry for Bellingham, and Bellingham Coal Mine boasted providing the largest payroll from a single company in all of the Northwest. Pictured here are some local miners by their excavator taking a rare break to pose by a loaded cart. Railways completely changed the industry, causing it to surge and fuel the city's need to connect its railways with the other major cities. Mining, however, was very high-risk business; besides being known for giving employees an illness known as black lung, cave-ins were always a consistent risk. On April 8, 1895, Washington's worst industrial accident to date, 23 workers died from a cave in at the mines.

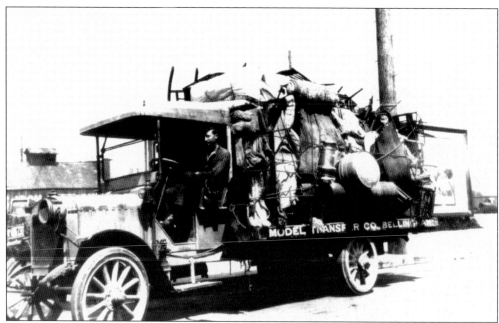

Model Transfer Co. was located on the corner of State and Magnolia Streets. The employee shown here driving the incredibly loaded vehicle is Jake Kruzer. Learning how to drive these vehicles was a new concept for many people, who were used to using horses for such tasks. Unfortunately, their historical building burned down in 1999.

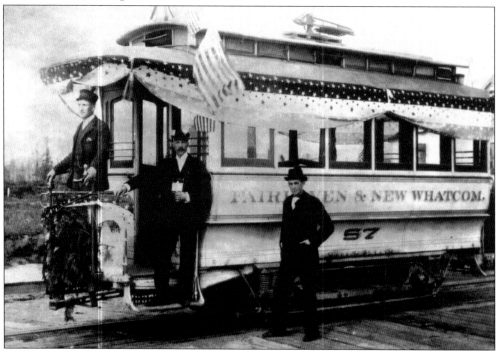

The local trolley system extended from New Whatcom to Fairhaven. The trolley line follows South State Street into Fairhaven before swinging onto Eleventh Street. There are still some tracks in the street where State Street turns into where Finnegan Way and Eleventh Street split off.

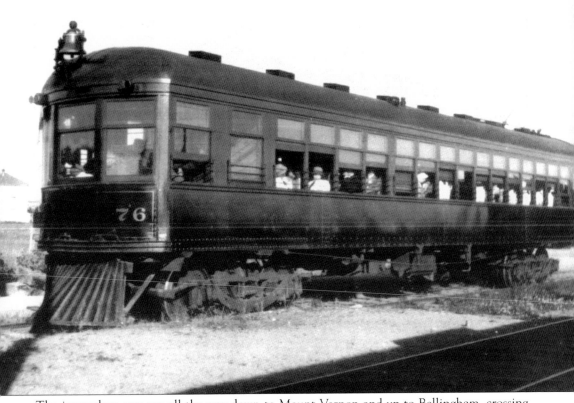

The interurban cars ran all the way down to Mount Vernon and up to Bellingham, crossing Whatcom Creek into the fountain district. The groundwork for such a route was first mentioned in the October 14, 1903, edition of the *Weekly Blade of Whatcom*, but it was not until 1912 that the interurban drawbridge was built over Skagit River and the route completed. The very first trolley ran on August 31, 1912, and pictured here is the last day Car No. 76 was used, in 1929. Due to both Car Nos. 75 and 78 derailing, as well as the drawbridge being condemned as unsafe, the rail line was officially abandoned on June 1, 1930. Around the same time, trolleys would run down what is now Railroad Avenue, taking people to and from Canada.

When it came time to pick which city would be used as the terminal stop to cross the mountains to the east, Bellingham was believed to be the best choice. It is close to Canada, and the easiest pass through the mountains made it ideal. Ultimately Seattle was chosen, but with the help of Donovan and others, Bellingham survived and connected with Canada soon after.

This switch station is the symbol of what is left of one of the great transitions that shaped Bellingham's future—the development of its rail systems. From quickly made rails to logging camps, trolley systems in between towns, to the connection with Canada and Seattle, the railway system saved Bellingham. Today, though still important for transportation of travelers and product alike, the burden that once was solely the rail system's to bear has spread out among many other methods, and like this old structure, it has survived the test of time.

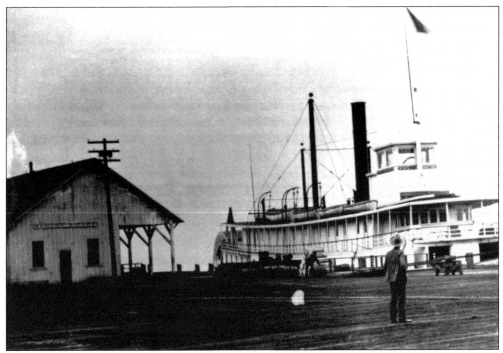

The *State of Washington* stern-wheeler was built in 1889 by John J. Holland. The vessel was assigned to the Seattle-Bellingham route since its first use until 1902. Here, it has just arrived at Sehome wharf in what is now a district in Bellingham.

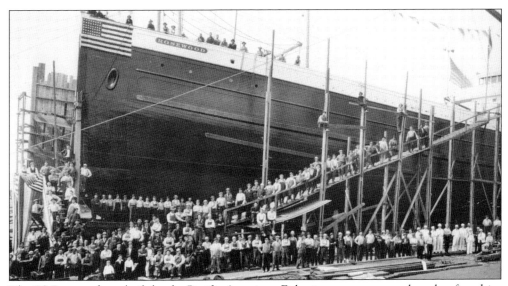

The SS *Rosewood* was built by the Pacific American Fisheries to accompany the other five ships they owned, including one purchased from the US Navy. They were used to make runs to Alaska, and on one of the vessels, salmon was canned right there on board. Shown here with the crew that built it, the SS *Rosewood* was launched on August 27, 1917.

Just a typical sized schooner docked at one of the world's largest processors of Pacific salmon, Pacific American Fisheries. PAF claimed a global market and had operations of regional, national, and even international significance. It contributed many significant innovations to the development of the industry, including floating canneries, mechanized salmon processing, and shipbuilding.

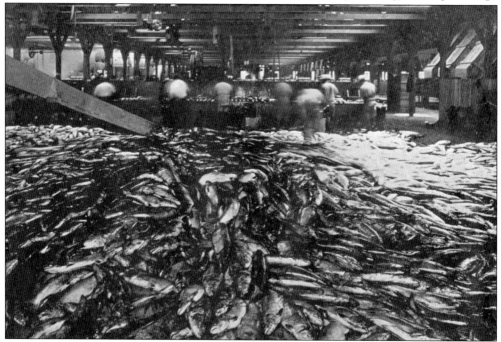

Pacific American Fisheries was one of the biggest industries of its time in Bellingham and one of the largest suppliers of canned salmon in the world. This required a large amount of fish to be brought in on a daily basis; pictured here is a daily catch of 80,000 salmon.

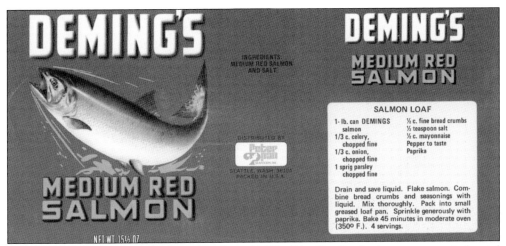

DEMING'S

INGREDIENTS:
MEDIUM RED SALMON
AND SALT.

DEMING'S

MEDIUM RED SALMON

DISTRIBUTED BY

Peter Pan
SEAFOODS INC.

SEATTLE, WASH. 98104
PACKED IN U.S.A.

MEDIUM RED SALMON

NET WT. 15½ OZ.

SALMON LOAF

1- lb. can DEMINGS salmon	½ c. fine bread crumbs
1/3 c. celery, chopped fine	½ teaspoon salt
	½ c. mayonnaise
1/3 c. onion, chopped fine	Pepper to taste
1 sprig parsley chopped fine	Paprika

Drain and save liquid. Flake salmon. Combine bread crumbs and seasonings with liquid. Mix thoroughly. Pack into small greased loaf pan. Sprinkle generously with paprika. Bake 45 minutes in moderate oven (350° F.). 4 servings.

Pacific American Fisheries, which was bought in 1965 by Peter Pan Seafoods, was once an industrial giant. This example of a label that was used during the time when canned fish was at its highest point sports the name of one of the company's owners and a recipe.

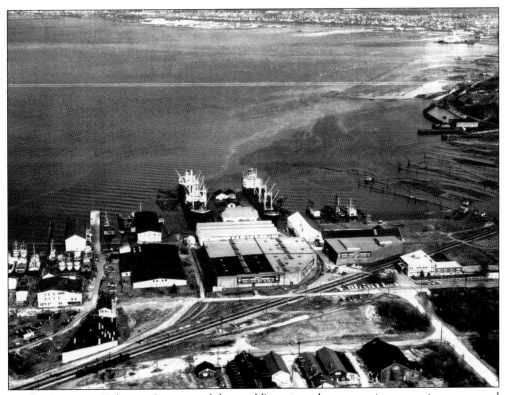

Pacific American Fisheries, Inc. one of the world's major salmon canning operations, operated on Puget Sound and in Alaska between 1899 and 1965, with headquarters in Bellingham, Washington. PAF had a rocky start but soon boomed and grew exponentially, eventually having five ships under its command.

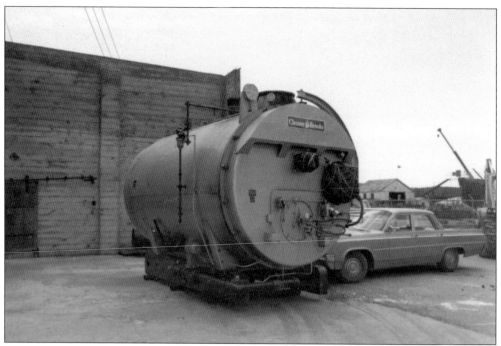

The boiler was the first piece of equipment brought in by Peter Pan. This particular boiler, while being unloaded into what is referred to as its crib, broke the cable and dropped a whole foot. Luckily, it was not damaged, or else there would not have been any canning done for almost a year.

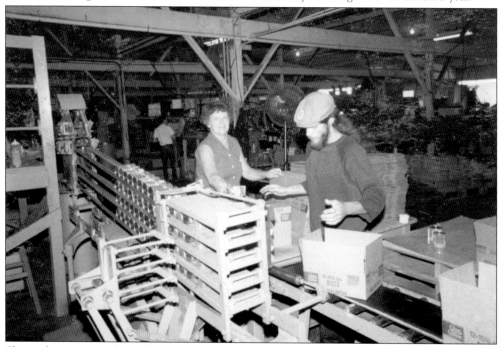

Shown here is Dorothy Fullaway, one of the many employees that worked behind the scenes, working with a PAF casing machine, Unfortunately, her father, who also worked at PAF, had a heart attack at 70 while loading cases of salmon into a boxcar. Each case weighed around 78 pounds.

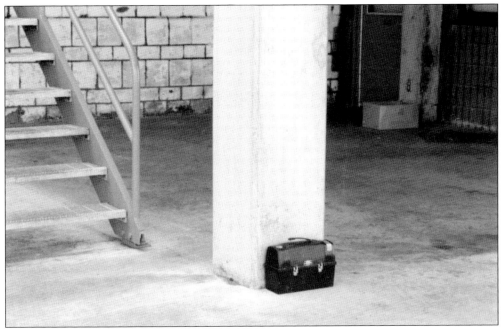

This lunch box belonged to a man who came from a family of fishermen and was one of the last Pacific American Fisheries employees in Bellingham. It symbolizes the emotion that comes with the ending of an era that supplied jobs to many locals for so long.

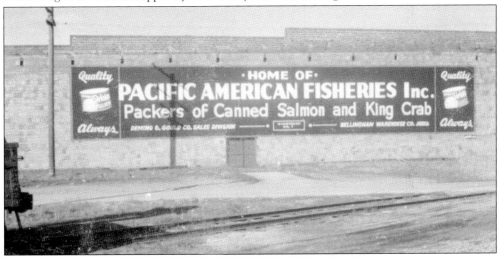

The headquarters for Pacific American Fisheries, this was the hub for one of the world's largest salmon canneries. PAF did business on the global market and not only had local operations, but also national and international significance. Its beginning was humble, however, starting off as a little cannery called Franco-American North Pacific Packing Company. It was founded in 1898 by Roland Onffroy and sold after a year to brothers from Chicago, Frank and E.B. Deming. Purchasing the Northern Fisheries in Anacortes as well, they were organized to start Pacific American Fisheries. For the next 66 years, PAF grew substantially, especially in the early 20th century, eventually expanding from the Puget Sound all the way to Alaska. Fast-forwarding to 1966, the closing of PAF marked the end of an era, and the property was sold to the Port of Bellingham; it is now the location of the Alaska Ferry Terminal.

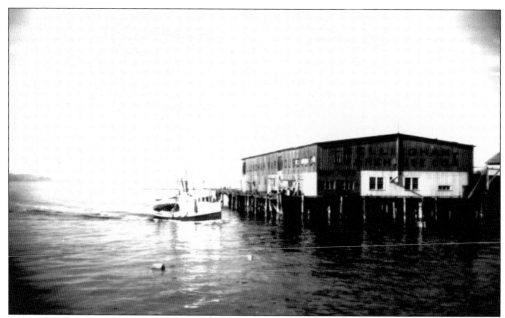

Bellingham Warehouse was located at the bottom of Taylor Avenue and was used most of the time to store salmon. It originally belonged to a relative of the Deming family and was common place among others. Many fires and the rebuilding of homes and businesses have changed the landscape of the Bellingham Bay shoreline.

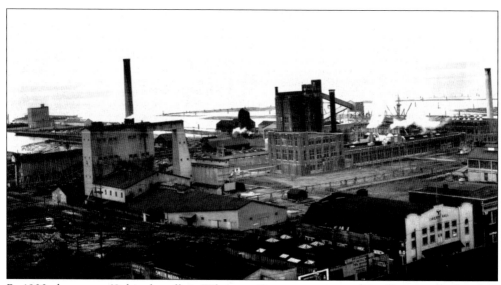

By 1900, there were 68 shingle mills in Whatcom County, outputting $5 million worth of product in one year. Puget Sound Sawmills & Timber Co. was the largest shingle mill in the world, producing 135 million shingles in its first year of the 20th century. Bellingham Bay was a bustling port with huge ships hauling timber, lumber, and shingles around the world.

The factories and businesses along the water created many different products, but unfortunately, that was not all that was produced. In this photograph, an excessive amount of waste is being spilled into the water. This waste is an example of what has created a mercury-poisoned sediment over the years that, to this day, is unable to be dredged.

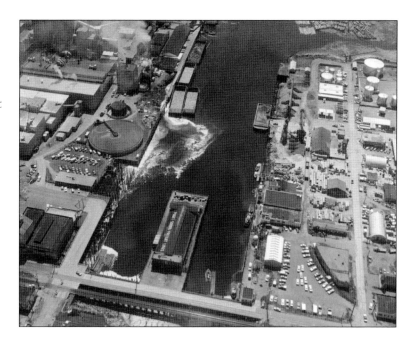

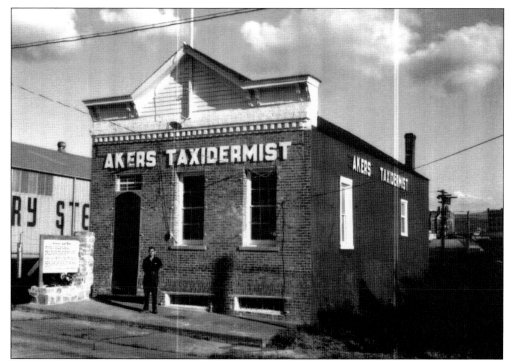

Thomas G. Richards and Company built this building in 1858, deeming Bellingham "the next San Francisco." Carl Akers is pictured here in 1955, almost 100 years later. Akers purchased the building, which housed his successful taxidermy business until he outgrew it in 1969.

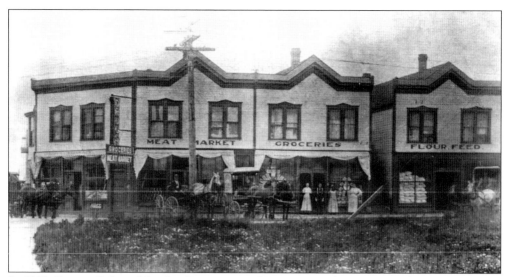

In 1909, George Cole and Linden Brown opened Brown & Cole Inc. in Lynden, making it the oldest supermarket in Washington. Three years later, they opened this second store when they purchased Setzer's grocery store and meat market on the northwest corner of Iowa and James Streets. John and Annie Setzer opened shop in 1904 and lived above the store until they sold it. Though the names of the new owners, Cole and Brown, might not be well known today, some of the names of stores they have owned are Food Pavilion, Cost Cutter, Save on Foods, Food Depot, and the Markets.

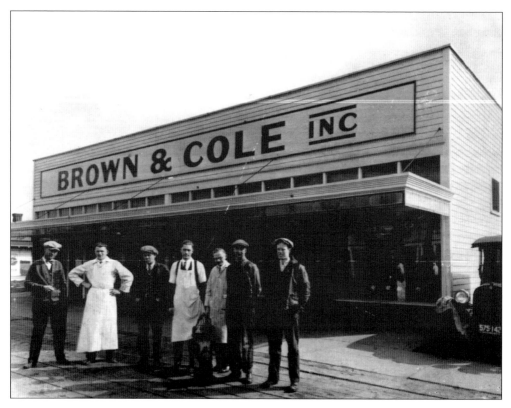

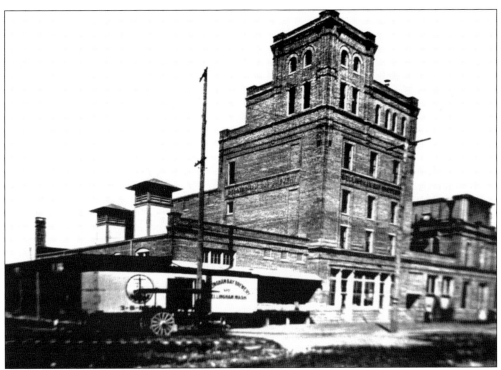

In 1901, Leopald Schmidt, president and owner of the Capital Brewing Company, decided to open up a brewery in Whatcom, which later became a part of Bellingham. Henry Schupp, a good friend of Schmidt's and business associate, was entrusted to manage the new site. Bellingham Brewery Co. only took 10 months to build, starting on January 10, 1902, and opening on November 28.

The Tulip Creamery of Bellingham was started in 1921 by William W. Fairburn, during the height of tulipmania. Disregarding the fact that the tulip industry in Bellingham was on a downward spiral, the creamery became known for its high quality of Tulip-brand ice cream, butter, and similar products.

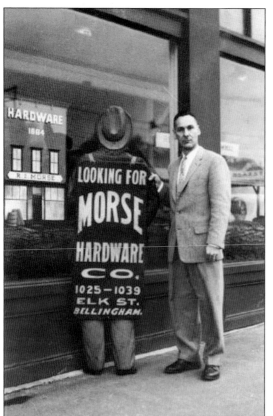

Morse Hardware Co. was a large hardware store, a historical Bellingham predecessor of modern home improvement stores. Shown here is David Morse, who was the youngest of Robert I. Morse's boys. Cecil Morse, the oldest son, ran the store and worked side by side with David until he passed in 1958 and David's son Robert took over. Currently, Robert's son Mike runs the business.

Pictured here are pioneers of the telephone business in front of the telephone building on January 1, 1925. The first service company in Bellingham was the Sunset Telephone Company. Whenever there was a long distance call, they would look up how much it would cost and then send someone on a bicycle to the residence to pick up the payment.

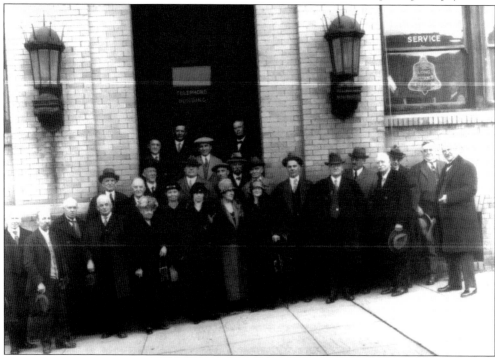

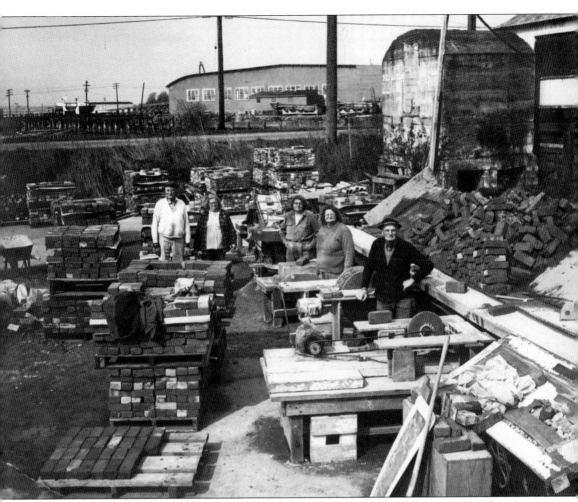

The Fairhaven Hotel, once the pride of Fairhaven and the most profound landmark for the area, eventually started to suffer structurally, and after a great fire in 1953 that completely devastated its interior, it was decided that it needed to be removed. In 1956, the demolition and removal of the Fairhaven Hotel was finished, and the bricks that were used to construct it were cleaned and salvaged. Throughout the 20th century, historical structures like this one were torn down for the sake of business. Besides the Fairhaven Hotel, many of the buildings in downtown Bellingham had been removed or suffered from fires. Some of those that helped with the teardown of the Fairhaven Hotel were the Slaughter sisters, as shown here center right. These bricks were later divided up and sold.

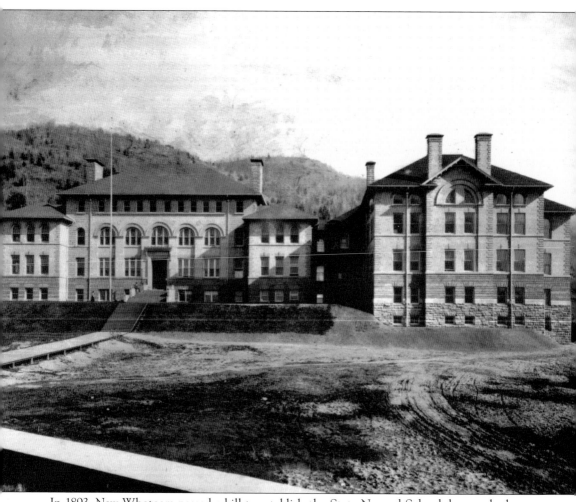

In 1893, New Whatcom passed a bill to establish the State Normal School, later to be known as Western Washington University. On September 6, 1899, the school opened with Edward T. Mathes as principal. With the merging of Fairhaven and Whatcom, the school changed its name to Washington State Normal School at Bellingham. As the years went on, the school steadily grew, and in 1933, it was authorized to grant a bachelor of arts in education. Soon after this, school board president Charles H. Fisher was terminated by the board of trustees. After casually stating to an editor at the *Bellingham Herald* during a party that Soviet bonds pay back five percent, word was spread that Fisher was anti-American. The school continued to grow, and it was renamed Western Washington University in 1977 after it was established as a college of business and education.

Washington State Normal School

Bellingham, Washington

To all to whom these Letters shall come Greeting

The Board of Trustees of the Washington State Normal School
on recommendation of the Faculty and by virtue of the
Authority vested in it by Law has conferred upon

David F. Dunagan

who has satisfactorily completed a four year College course the Degree of

Bachelor of Arts in Education

with all the Rights, Privileges and Honors thereunto appertaining

Given at Bellingham in the State of Washington this eleventh

day of June, Nineteen Hundred and Thirty Six

W.D. Kirkpatrick
President of the Board of Trustees

C.H. Fisher
President of the Normal School

Shown here is a diploma awarded in 1936, only the third year that such diplomas were available, and one of the last under the name of Washington State Normal School of Bellingham. The following year, the name changed to Western Washington College of Education, a name held until 1977, after a large amount of hard work and progression in curriculum merited a change to its current name, Western Washington University.

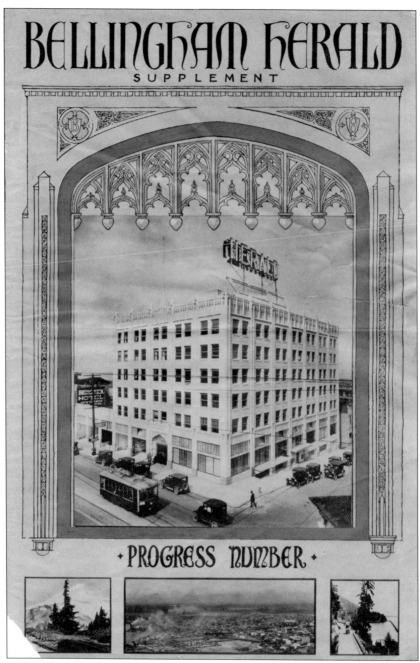

BELLINGHAM HERALD

SUPPLEMENT

· PROGRESS NUMBER ·

The first Herald Building was finished in 1890, and it was located off of Larrabee Avenue in Southern Bellingham and once housed what was considered the best printing house in Washington outside its three main cities. At that time, the paper was called the *Fairhaven Herald*, and it went through many changes, a merger, and even a suspension during its earlier years. It was not until the 1903 merging of New Whatcom and Fairhaven into Bellingham that the newspaper's name was changed to the *Bellingham Herald*. Pictured here in 1926, over 20 years later, the Herald Building stands tall and proud on the corner of State and Chestnut Streets, housing the one newspaper that has not only survived the test of time, but thrives.

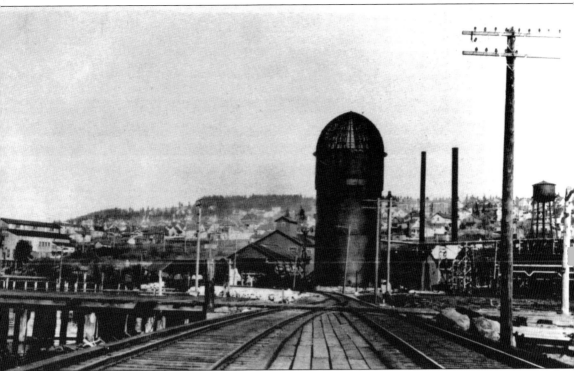

In the 1930s, the Puget Sound Mill's domed incinerators rested at the foot of Harris Avenue. A symbol of industry, it unfortunately was a mill known to be home of many bad accidents. With the lack of proper safety precautions and procedures, many of these accidents ended in amputation and sometimes death. It was common in industries such as the Puget Sound Mill to have employee's safety depend on the range of their common sense. Due to workload, many were not properly trained to use the dangerous, yet common, equipment. One of the things that increased this demand was the rail system, such as the one here in the center. Once connected to the Northern Pacific, it forever changed how business was done for Bellingham.

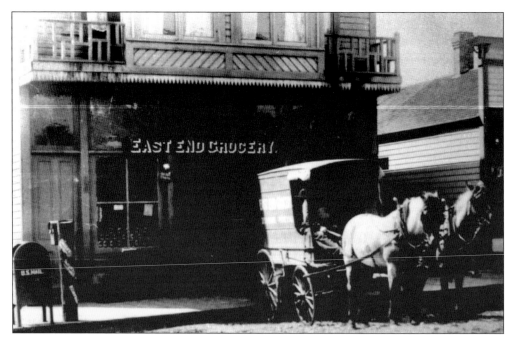

With so many people flocking to the Bellingham area because of the gold rush, coal, or to work in the mill, the boom in economy caused many shops to open up to service the township. East End Grocery, one of these businesses, was located out on Twentieth Street, and its last owners were the Hinotes family.

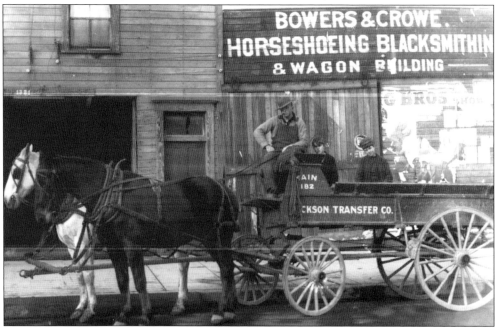

In the late 19th century, wagons were crucial to keep up with the boom in industry. This raise in economic sustainability supported blacksmithing businesses such as Bowers & Crowe, located off of what was Elk Street, now State. Shown here is a wagon from Jackson Transfer Co. having work done.

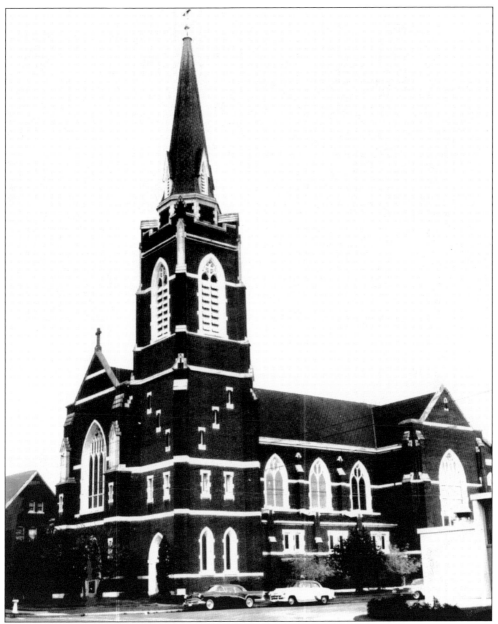

In 1889, the Church of the Assumption was established as a parish on State Street at the intersection of Cedar Street by Bishop Aegidius Junger, with Fr. Jean Baptiste Boulet as its first pastor. At the time, this area was central for Catholics in Whatcom County's bay towns. The structure standing today, however, was not erected until 1920. As shown here in the 1950s, the Church of the Assumption was moved when the school was being built on Cornwall Avenue and stands tall and much unchanged. In 2000, there were many repairs, and both a chapel and gathering area were added. The Church of the Assumption is one of the iconic landmarks of Bellingham.

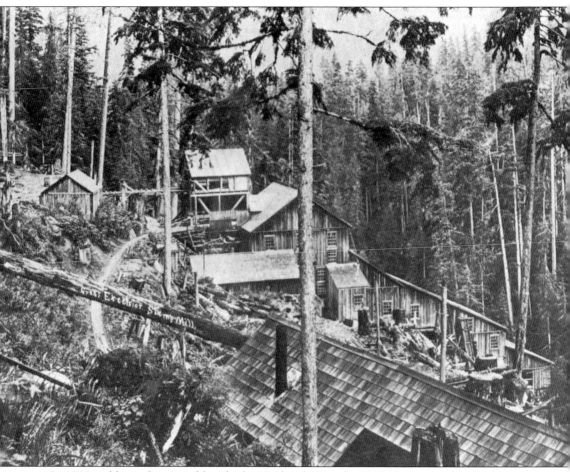

In 1900, gold was discovered beside the Nooksack River by W.H. Norton, and a year later, the Great Excelsior Mine was built. Toward the end of 1902, the first gold bricks were shipped to Seattle along with a promise of many more to come. Unfortunately, the Mount Baker gold rush proved unfruitful, and in 1905, the mine was purchased by Hugh Eldridge with the President Group Mining Company. Even though the mine was shut down in 1916, the gold rush caused Mount Baker to be much more easily accessible, key to Bellingham's tourism as well as allowing other smaller towns a chance at development.

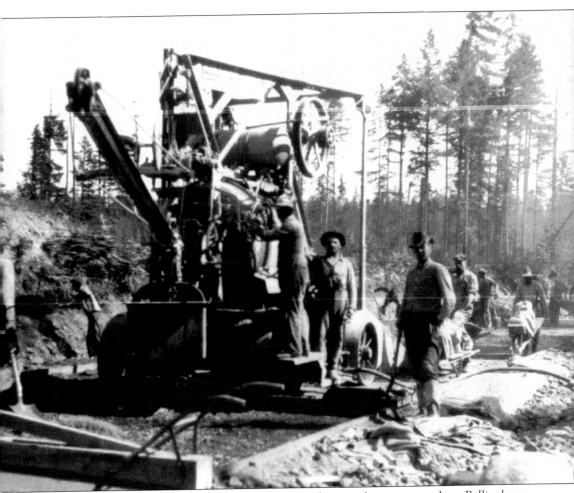

Chuckanut Drive is one of Bellingham's beautiful scenic drives and connects southern Bellingham with Mount Vernon; however, it was not always this way. Originally little more than a glorified trail in the 1860s, it was only passable during low tide until 1896, when it was turned into a logging access road. Later, in 1907, as it slowly became more viable, it was named Waterfront Road. In the 1920s, after many man hours put into its construction, upgrades, and repairs, it was connected to the Fairhaven district under the funding of C.X. Larrabee and his partner Cyrus Gates. Shown here are hardworking laborers covering the drive with cement. Hired laborers were not how all of the road was built, however; further south toward Mount Vernon, prisoners were used for their labor to continue the task in the harsher, more-distant parts until it was finished.

Pictured here is Fairhaven Pharmacy back in the 1940s, a look at what it was like inside the oldest pharmacy in Bellingham. First started by D.P. Mason in 1889, the business has been passed down to several different owners and moved before settling into its current location at 1115 Harris Avenue in the Fairhaven district.

Gordon "Gordy" Tweit is shown here in the year he bought the Fairhaven Pharmacy, 1962. Gordy had worked in the pharmacy before purchasing it from Rene J. LaCasse. To this day, Gordy hosts a private museum of images and artifacts from the Fairhaven district and Bellingham area.

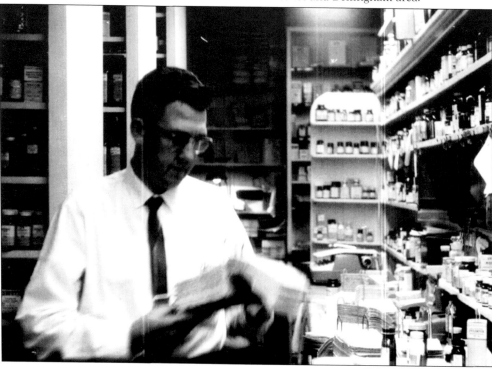

Five

THE CITY OF SUBDUED EXCITEMENT

Bellingham is certainly one of Washington's secret masterpieces. Resting off the bay with the San Juan Islands on its western horizon, to the mountains and myriad of trails that run through and around its landscape, makes it the ideal city for both someone with an adventurer's heart and the bookworm that wishes to nestle down, submerged in its peaceful beauty. Bellingham is a city that simply feels like home.

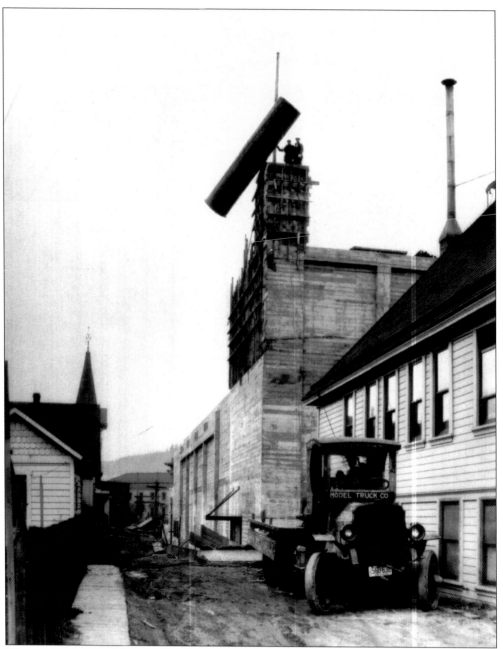

The construction of Mount Baker Theatre, which was part of a nationwide movement to build magnificent theaters, took over 80 craftsmen experienced in carpentry, masonry, and plaster casting. Shown here is the placement of the boiler in its last months of construction. Mount Baker Theatre, one of the greatest buildings in Bellingham at the time, opened its doors on April 29, 1927. Over the years, the appeal of grand theaters dwindled, and due to the economy, the once magnificent structure started to show its age. In 1978, Mount Baker Theatre was placed in the National Historical Landmark Register. With the dedication and funding of many people, Mount Baker underwent a massive restoration and remodeling. In September 1996, Mount Baker Theatre had its grand reopening.

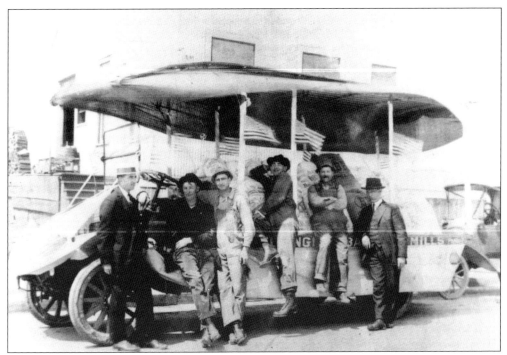

Parades have always been very popular in Bellingham, and many of the local businesses would decorate their vehicles or make floats to take advantage of the easy advertising. Bellingham Bay Flour Mill was no exception, as shown here with employees posed around their float.

As Bellingham continued to grow, continually on the verge of various economical surges in growth, it attracted many different businessmen and leaders of the surrounding community. Shown here is an entourage being escorted by police and attracting many people to watch them go by. This photograph was taken up by the college off of Forest Street by a Mr. Peterson.

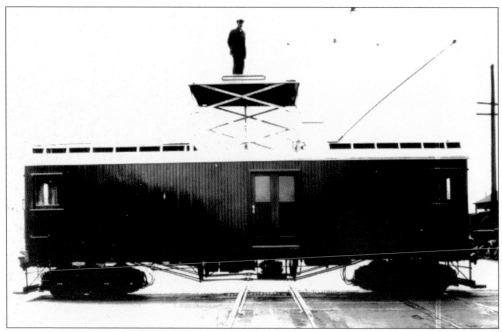

Beware of Chance Acquaintances

"Pick-up" acquaintances often take girls autoriding, to cafès, and to theatres with the intention of leading them into sex relations. Disease or child-birth may follow

Avoid the man who tries to take liberties with you He is selfishly thoughtless and inconsiderate of you

Believe no one who says it is necessary to indulge sex desire

Know the men you associate with

The interurban trolley carried passengers between Mount Vernon and Bellingham Bay from 1889 to 1903 above what is now Chuckanut Drive. Due to the increasing use of automobiles and the development of Chuckanut Drive, the interurban trolley eventually was abandoned, and its tracks were later converted into a hiking and biking trail.

An awareness poster designed by the American Social Hygiene Association in 1922 tells ladies that they need to look out for "pick-up" acquaintances that might treat them with the sole intention of selfishly taking "liberties with them." Bellingham was somewhat notorious in its early years for its brothels, having at least 27 between the late 1800s and the 1940s. Posters like this one could be found as commonplace in both grocery and drugstores, encouraging a change in this social normality.

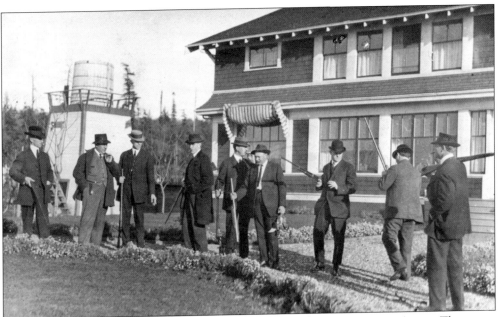

Out at Lummi Island, this local Bellingham club went bird hunting by the fisheries. This group consisted of businessman and doctors. Though a common pastime in the 1950s, it can clearly be seen that some of the members were more experienced in handling firearms.

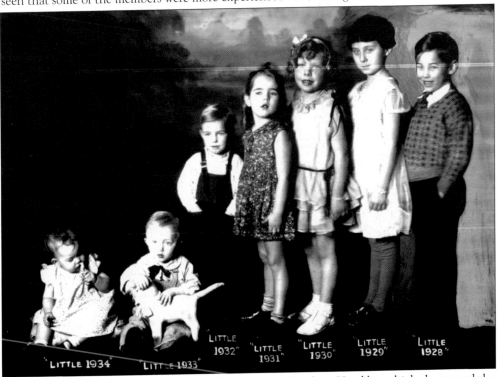

"LITTLE 1932" "LITTLE 1931" "LITTLE 1930" "LITTLE 1929" "LITTLE 1928"

"LITTLE 1934" "LITTLE 1933"

The "New Years Babies" was a fun piece done by the *Bellingham Herald* in which they posed the very first children to be born in the Bellingham area together for each year from the year 1928 to 1934. It was something done for fun and enjoyed by many of the locals.

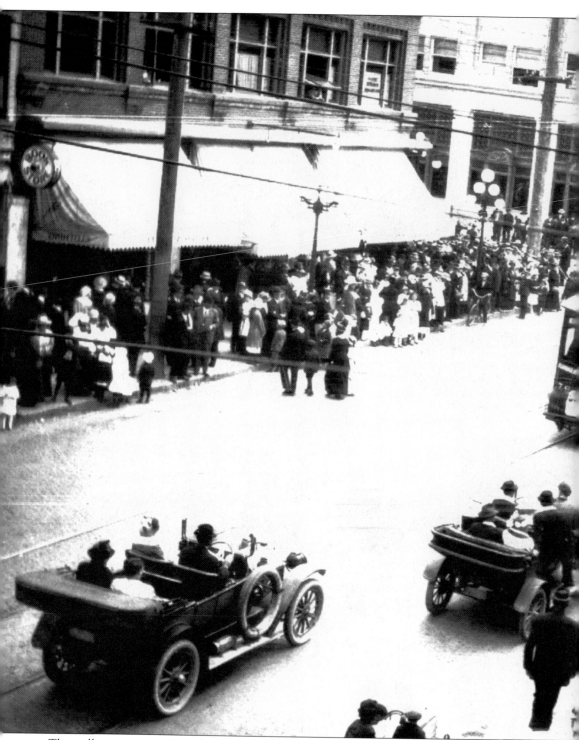

The trolley system was the only mode of public transportation used in Bellingham and cost 10¢ to hop on and take a ride from Holly Street to Eldridge Avenue. The trolleys moved faster and quieter then the cars, and once one reached the end of its line, the conductor would get out and

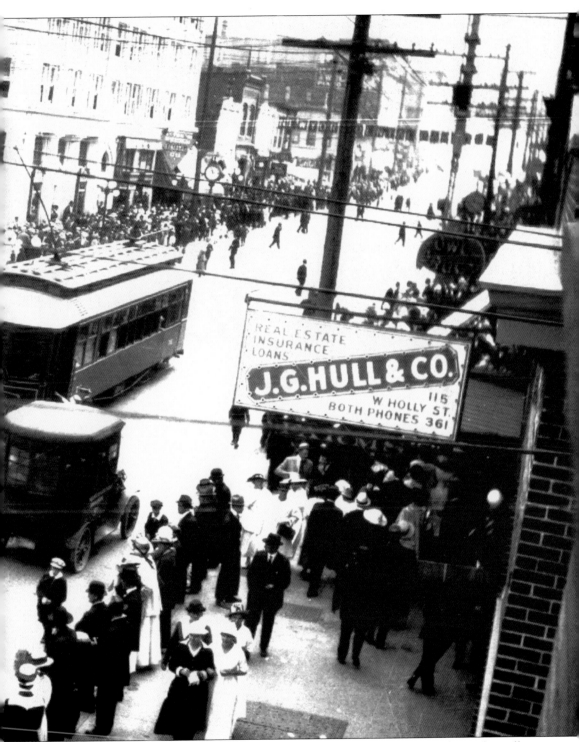

move the electric wire to the other end of the trolley and head back down. Utilizing the trolley system was a very popular and inexpensive way to travel.

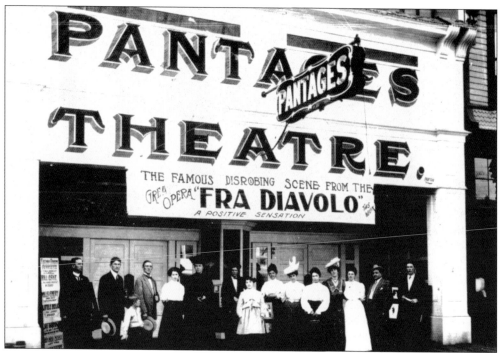

The Pantages Theatre was one of the great theaters of Bellingham, opened by Alexander Pantages. This image was taken in 1906 during a time when grand theaters were a sign of a city's prosperity. Located off of State Street, many cast members of the current production, as well as others, are seen standing in front of the theater.

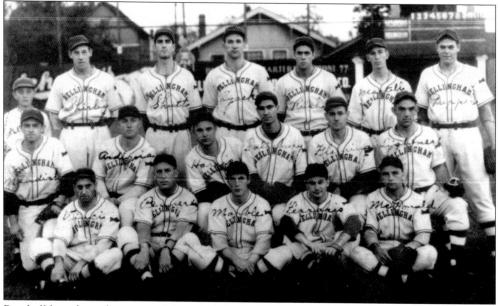

Baseball has always been one of America's favorite pastimes, and Bellingham was no exception. The 1938 Bellingham Chinooks Baseball Club was one of Bellingham's earliest baseball teams. This team featured a number of former and future Major Leaguers and played their home games at Battersby Park in Bellingham.

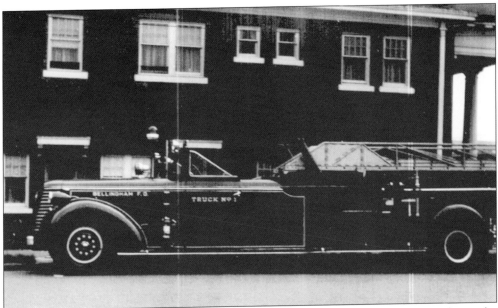

Fire Truck No. 1 is shown here sitting outside of the mortuary building. In the 1940s, due to the increasing size of buildings, ladders started to be attached to the trucks. It was not until after World War II that buckets were invented, yet the turntable platform still allowed some of these trucks to reach as far up as 150 feet (46 meters).

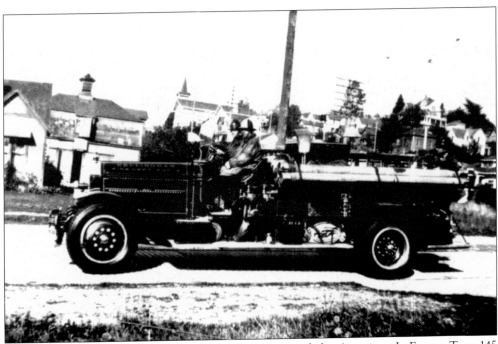

A great example of a late-1920s model, Bellingham used the American LaFrance Type 145 throughout the mid-1930s, as shown here. The truck hosted a 1,000 GPM rotary gear two-stage pump as well as an 80-gallon tank. This truck was used many times before being retired.

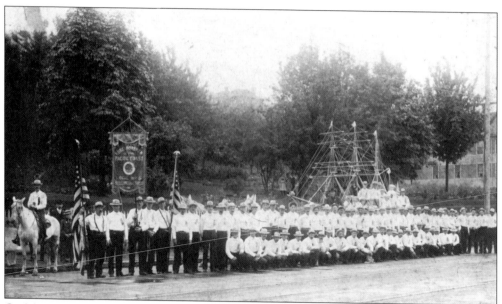

On May 9, 1934, Bellingham participated in the most significant waterfront strike in American history. Shown here are the local members of a strike that lasted two and a half months. The employees working out at the ports thought they were being treated unfairly, and under the guidance of the International Longshoremen Association they were able to rally together and prevail.

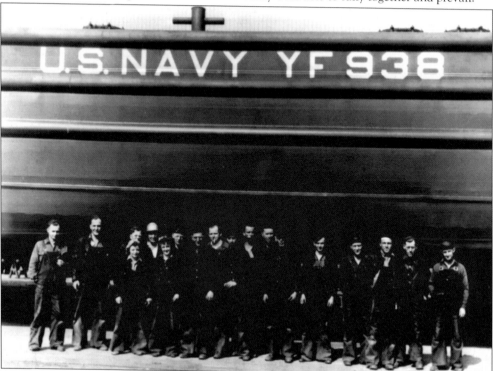

This ship, the US Navy YF 938 was located in the north side of Bellingham. In the main shipyard, minesweepers were built for both the United States and England. On display, the US Navy YF 938 is shown here with some of those that built her posing in front.

Still the State Normal School at the time this was handed out, *The Messenger* was a yearbook for students. This copy was for June 1912, at a time when school terms cost 75¢ a year. Written just inside was a dedication to the class of 1912 stating, "To the spirit of progress and to the social uplift movements of the Twentieth Century."

The Messenger
JUNE 1912

The school's football team of 1911–1912 was the very first team in the school's history to defeat the local high school. This was largely due to the fact that in normal school, they had to put a new team on the field each year. The cheer for the team was "Hippety-hip! Kazip! Kazip! Hippety-hip! Kazip! Kazip! Hooray! Hooray! Belay! Belay! Bellingham Normal! Bellingham Bay!"

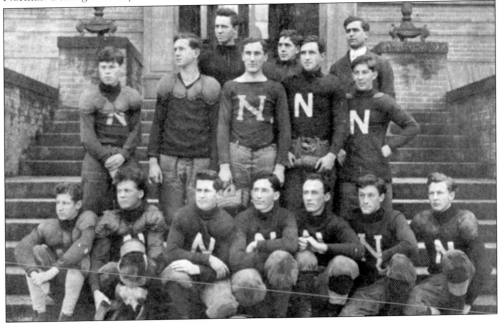

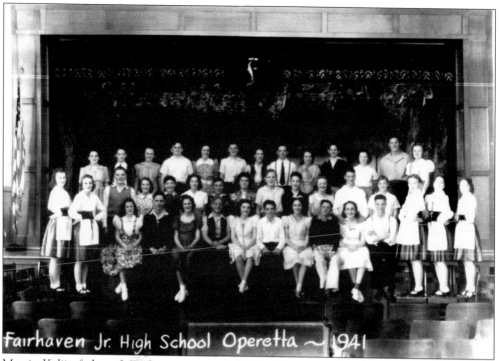

Fairhaven Jr. High School Operetta ~ 1941

Martin Kuljis, father of our current mayor Kelli Linville, is seated here in the front row, eighth in on the right. "The Chocolate Soldier" was a popular song performed by the Operetta during the 1940s, as well as many others.

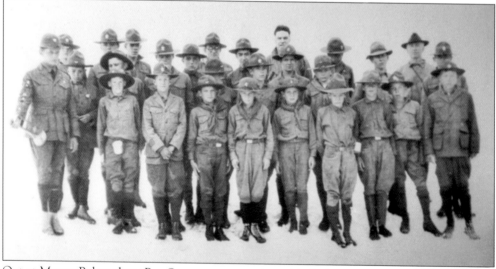

Out at Mount Baker, these Boy Scouts were camping with their scoutmaster, a Mr. Green. Boy Scouts was an ever-growing popular activity among the youth as a way to experience the outdoors. It was an easy way to teach the next generation how to be self-reliant and the importance of always being prepared. Sometimes, like the boys shown here, that means camping in the snow. One of the advantages that not only came out of the gold rush, but also after all the lumber mills and mines cleared out pathways, Mount Baker started to be regularly used for outings by the locals and as a tourist attraction to draw people from afar.

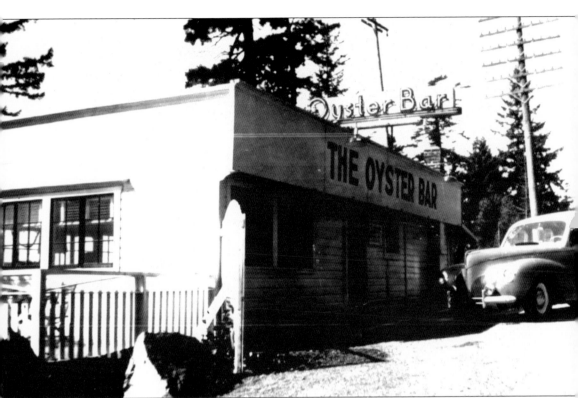

Otto Amos bought the Rock Point Oyster Company in 1946 from the Maekawa family. Otto's wife renamed it the Oyster Bar, and they coined the slogan "The oysters that we serve today slept last night in Samish Bay." The Oyster Bar was a popular destination just outside the city of Bellingham and has had numerous owners since the Amos family.

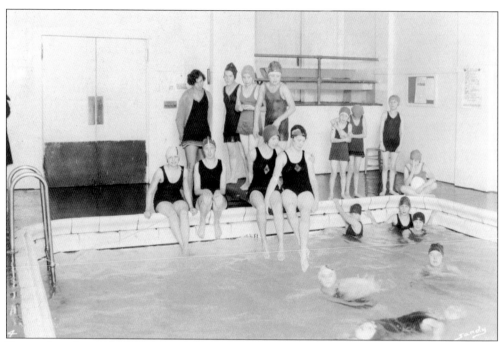

Frances Larrabee was a prominent and influential woman of Bellingham. She was married to C.X. Larrabee, but more notably, she was responsible for the opening of a state park in her husband's name and the founding of the Bellingham Bay home for children and was the main benefactor and influence in establishing a YWCA in Bellingham, as seen here.

In the 1920s, the Rockpoint Oyster Company went into business off of Samish Bay, but due to the Great Depression, it became difficult to sell oysters. Desperate times led to desperate measures, so the company set up a little shack right off Chuckanut Drive. Rising in popularity this shack turned into a small restaurant, and after several owners, it steadily grew and matured, ending up as one of the treasures of the Bellingham area.

In a glimpse of Bellingham in the 1970s, Rene Lacsse is picking up some mail by a police phone. On this block, there use to be a police officer that patrolled the area and had an office across the street. There was much confusion with locals thinking that there was an actual police station on site.

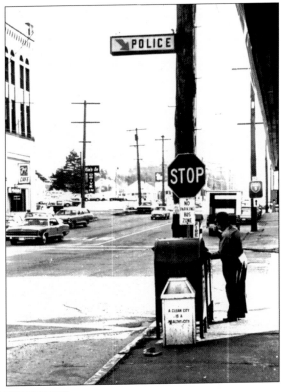

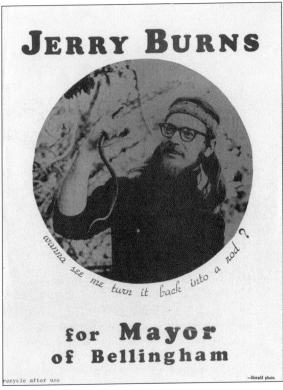

Jerry Burns was an announced candidate for mayor of Bellingham in 1971. He specifically tried to corner a hunk of the new crowd of 18-21-year-old voters when running against Reginald Williams. This image of Burns holding a snake reads, "Wanna see me turn in back into a rod?" Williams ended up winning the election.

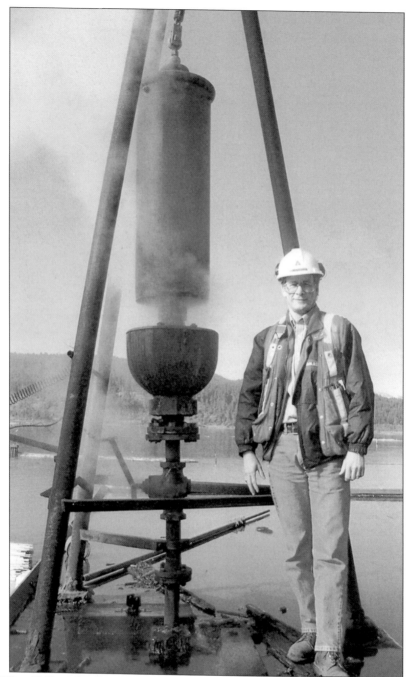

From 1897 to 1943, a whistle named "Ollie" was used at the Bloedel Donovan lumber mill to tell people the time. It was often that many people would set their watches to the Ollie, which could be heard all over Bellingham. It would whistle at 12:00 p.m., 1:00 p.m., and 5:00 p.m. After the whistle was retired from Bloedel Donovan lumber mill, it was sold to a company in Canada. Later, it was brought back to Bellingham, and even though a portion of it was cut off and removed, it was placed in the museum before finally being taken to WWU. Currently, the whistle Ollie is used for emergency notifications at the school campus.

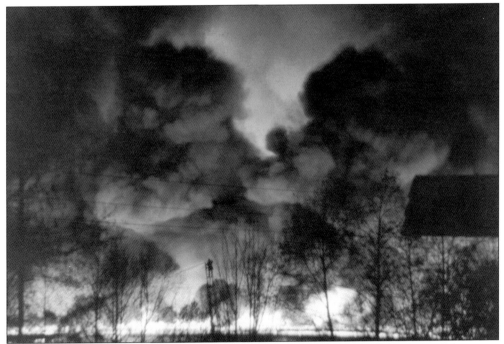

On April 8, 1980, the Uniflite building caught fire and required 60 firefighters just to keep it at bay. Shown here is Rob Neale using a hose to keep two tanks of acetone and a railcar load of plastics cool so that they would not blow up. This image has been used locally from then on as an example of what not to do.

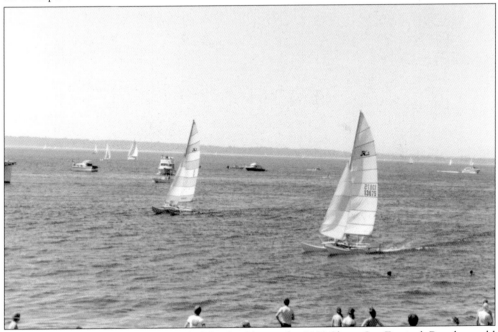

These racing sailboats are at the end of the final leg in the 1983 Ski to Sea Festival. People would line the shore, watching as the boats went head to head. The first three teams to cross the finish line were Red Robin & Mammy Jammers, Pacific Water Sports, and Osborn & Ulland.

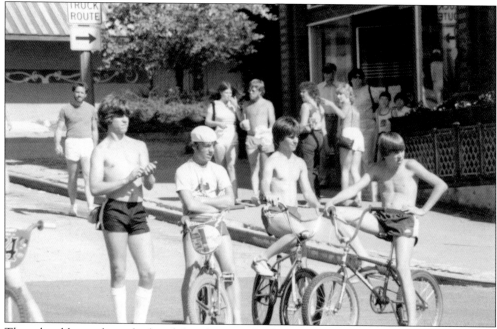

These local boys who rode their bikes down to the festival are a perfect example of what it was like to grow up in the early 1980s. Ski to Sea has its roots going as far back as 1911 with the Mount Baker Marathons, but it was not until 1973 as an event for the Blossom Time Festival that it became what it is today.

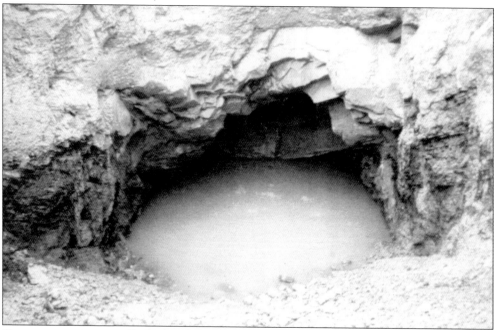

On a construction site off of Bellingham Bay, a hole appeared that was discovered to be leading toward what was once Pattle's 1853 mine. The entrance was on the northwest corner of Tenth Street and Taylor Avenue and had to be filled in to commence construction. It is now the location of the Chrysalis Inn.

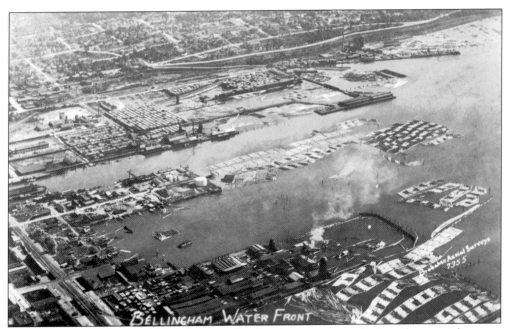

Shown here is downtown, where the Port of Bellingham was located when these aerial surveys were taken.

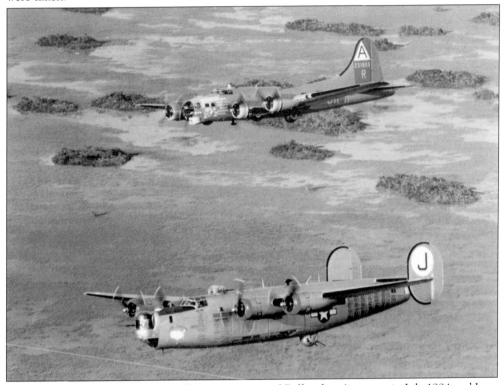

A B-17 Nine-O-Nine and a B-24 All American visited Bellingham's airport in July 1994 and June 1995. These aircraft were on tour so that individuals would be able to fly around the Bellingham area in them.

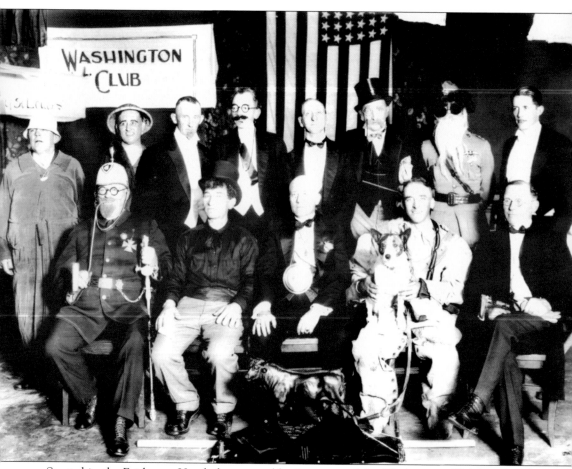

Started in the Fairhaven Hotel, doctors and businessmen of the Washington Club loved to do roasts, when an individual openly and willingly listens to the creative and often funny insults and defaming comments for the fun of it. One notable roast was that of a female pastor, who was so insulted, she decided that she wanted to get even. In turn, she invited them to church and proceeded her own roasting. Their bull was made locally and was a sort of mascot for the club, but it was stolen once the group moved to the Bellingham Hotel.

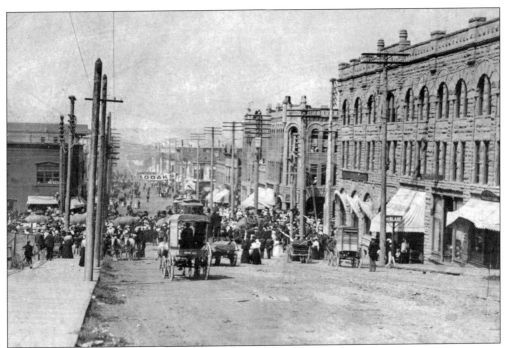

On June 3, 1930, the Al G. Barnes Circus came to Bellingham as one of their stops while on tour of the country. Word traveled like wildfire, and people flocked around to watch as they came into town, elephants in tow, to set up their very first show.

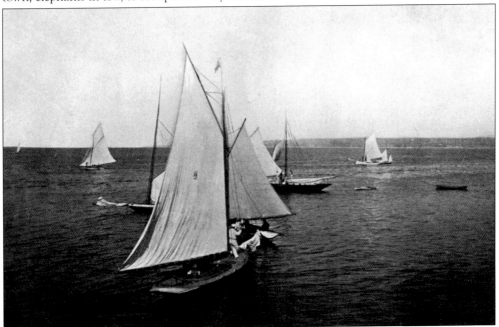

Starting as far back as 1877, yacht races have taken place in the bay. The most notable early race occurred on July 5, 1891, to commemorate the arrival of the Great Northern Railroad. In August 1892, seven yachting clubs met in Fairhaven and formed the Northwest International Yachting Association; races have happened ever since.

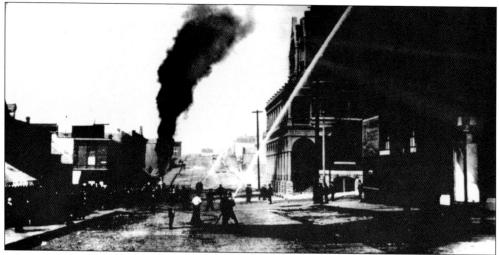

After Seattle's great fire of 1891, it was apparent that the methods and equipment used were insufficient to battle such fires. Nelson Bennett provided Fairhaven's Fire Department with brand new equipment. In the background, one can see the Fairhaven Hotel to the right as they practice using the pumper on the Mason Block.

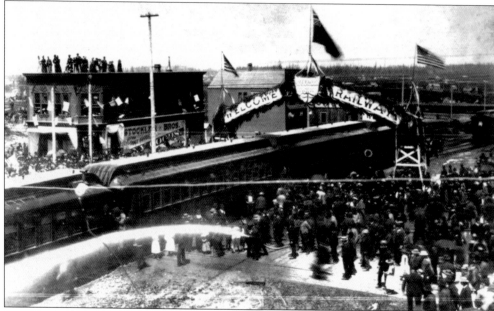

In 1891, thinking to celebrate a rail connection to Canada that would revive the town, one of the three railroads in the locale, the Bellingham Bay & British Columbia Railroad, hosted a major town reception for the representatives of the Canadian Pacific (CP) Railway on Railroad Avenue. Several thousand people assembled; the fire department was to create an arch of water over the train as it stopped at the terminal and the dignitaries disembarked. This was to be done using hoses from either side of the track. One brigade shot off their hoses prematurely, and not to be outdone, the other side let fly before time as well. The representatives of the Canadian Pacific disembarked into the middle of full-fledged water fight between the fire companies, to their considerable soggy dismay. Despite many apologies after this debacle, the railroad never did manage to connect to the CP.

In the early 20th century, the automobile changed the landscape of the world forever. From then on, motorizing other equipment and vehicles became normal. Motorcycles were soon to follow and were ever popular in Bellingham. Shown here is a man posing with what appears to be a motorcycle from the 1910s.

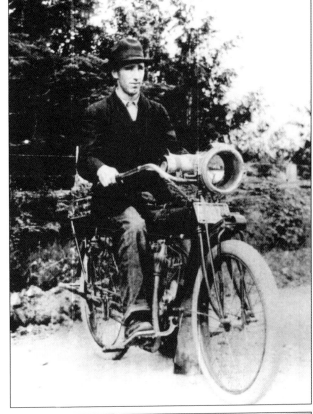

Fred Offerman was the owner of Fairhaven Pharmacy and is shown here with his recently purchased automobile off of Nineteenth and Larrabee Streets looking over Happy Valley. Being one of the first cars, if he was ever trying to go uphill, someone would have to get out and help push it up.

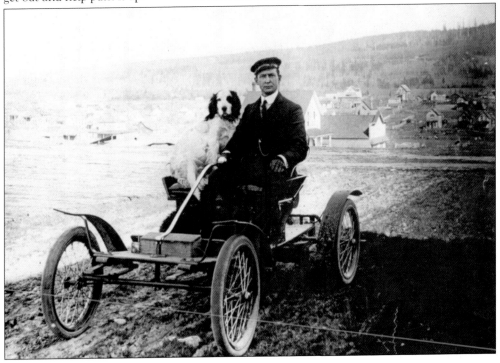

Due to the clearing of forest lands, by the 1890s, many crops started to flourish in what is now the Bellingham area. In 1907, the US Bureau of Plant Improvement, as well as the Holland American Bulb Company, were inspired by George Gibbs's success with his tulip farm, creating tulipmania. During this time, Bellingham collectively had thousands of bulbs.

Tulips became so popular that in May 1920, the Tulip Time Festival was organized and Tulip Queen crowned. The next year, there were 100,000 bulbs planted. The bulb industry and festival continued until 1929, when a series of severe freezes forced the removal of the industry to Skagit County.

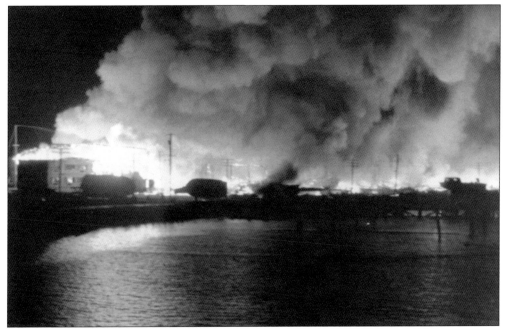

With a shoreline rapidly being covered with flame and smoke billowing out overhead, one can see the plywood plant that caught on fire. Unfortunately, this was not all that abnormal; over time, there have been numerous fires along the waterfront due to all the mills.

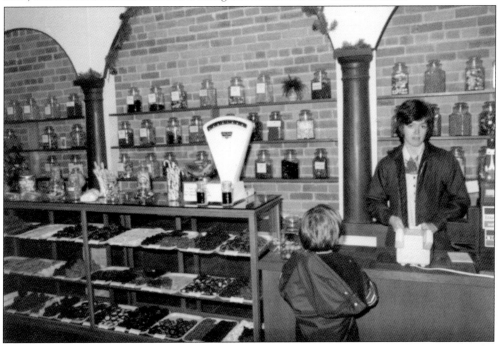

The Nutcracker Candy Shop, in a building now known as the market place, was located on the second floor. Shown in this photograph depicting what candy shops were like in the early 1980s, a Mrs. Kadd works the register. This Nutcracker Candy Shop was located within the Mason Block and was one of the first stores open for business.

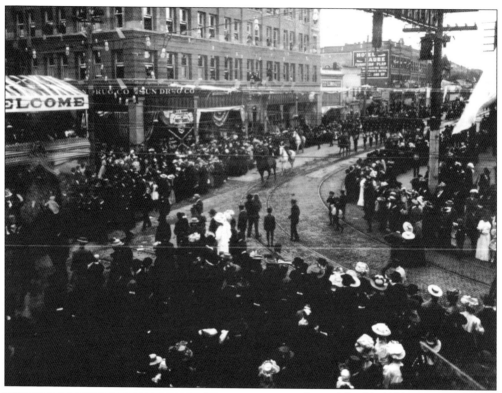

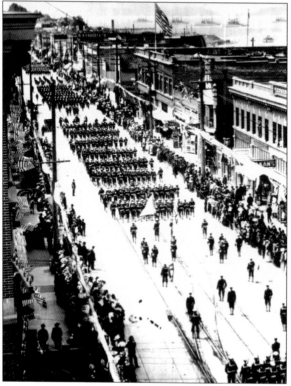

It was May 21, 1908, just after 12:00 p.m., when seven ships of the Second Squadron rounded Commercial Point and set their anchors in Bellingham Bay, making it the most northern point of the Great White Fleets cruise. Lt. Frank Radley, in charge of the National Guard, rendered a salute to the arriving fleet of 3,500 sailors and marines. The mayor of Bellingham was on hand to extend a formal greeting, and a welcoming committee quickly boarded the *Connecticut* and extended the greeting from the city to the officers and men of the fleet. Businesses that day were all suspended as 100,000 people flocked to Bellingham to greet the soldiers returning home. This event was and is the largest ever hosted by the city of Bellingham.

Six

THE SKELETON
IS IN THE CLOSET

Everything that produces light casts a shadow, and even a city as peaceful as Bellingham has a dark side. From its beginning, this fair city has dealt with Indian wars, riots, racism, and stone-cold killers mingling with its people. This chapter explores Bellingham's underbelly and the shameful secrets of its past.

THE BELLINGHAM HERALD

FULL ASSOCIATED PRESS LEASED WIRE SERVICE.

CITY OFFICIAL PAPER

BELLINGHAM, WASHINGTON, THURSDAY, SEPTEMBER 5, 1907

SIXTEENTH YEAR NO. 138

The Herald
Prints More
Reliable
Local News
Than All Its
Competitors.

INDUS HOUNDED FROM CITY

Drives Foreigners From Lodging Houses and Mil

DECLARES THAT GHTS OF HINDUS MUST BE PROTECTED

Chief of Police to ear in Fifty Extra Men

CK'S ADDRESS BEFORE THE COUNCIL.

Two Hundred Hindus Piled Into Room in the City Hall

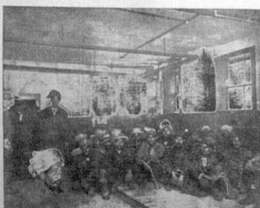

POLICE FORCE HELPLESS IN CRISIS

Mobs Control City Without Interference From Authorities—Hindus Crowded Into Basement of City Hall, While Police Make No Effort To Check Outrages.

CHIEF IS CRITICIZED

Public Believes That a Little Nerve On Part of Officers Would Have Check the Riot.

MOB LA RULES I CITY

Terrorized Indians Fly B Lawless Crowd—Brown Are Beaten While Police Paralyzed — Lodging Ho Are Raided and Inmates Dragged Forth and Order Leave Town.

MOBS SWEEPS MILLS ALONG WATERFR

Plant After Plant Visited Crazed Crowd—While Leave Posts and Join Indians Herded Togeth Marched To City Jail.

The infamous riot of 1907 was one of the great shames in Bellingham's history. Fueled by the economy's hard times, the locals took it upon themselves to self-righteously attempt to remove the Asian community of Bellingham. The locals organized themselves as a mob and proceeded to throw them out, sometimes literally, beating them and attempting to intimidate them to leave, and it worked. Even with the mayor hiring 50 extra officers and saying they would be protected, the Asian community knew there was only so much that could be done. Shown here is a portion of the Asian community that had been abused. (Author's collection.)

The Swastika Literary Society was formed in 1912. Originally selecting Ku Klux Klan (KKK) as their society's name, it was quickly shot down. They had to change it when the principal vetoed their choice, and the students had to think of a name that they could get away with using. They decided upon Swastika and were allowed to keep it under the guise that it was a symbol for good luck. This is an example of how, even in 1912, the views of the second KKK wave were taking root. It is important to note that the views of the KKK were seen as a moral stance, and the principles that they stood on justified an expected compromise from those that stood in their way. This fueled racism and discrimination as viable behavior toward those that unjustly deprived them of what was felt to be rightly theirs.

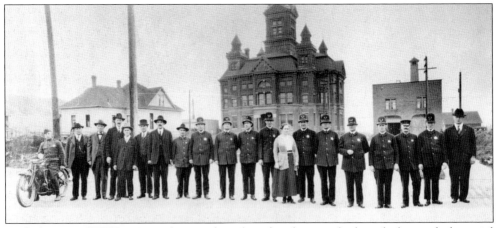

With the second KKK wave on the rise, the police played a crucial role in dealing with the racial tensions. Though certainly the least violent of the three waves, Bellingham possessed the strongest and longest lasting Klan in Whatcom County. With the Klan's secrecy and reach into politics, however, there could very well be a member in this photograph.

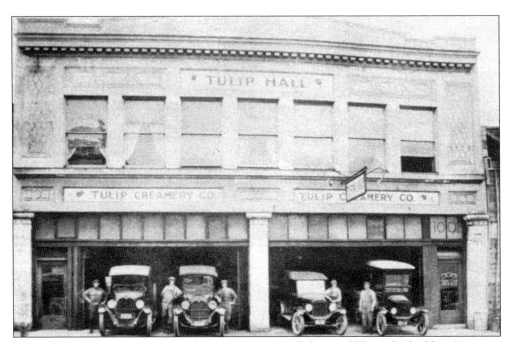

The Tulip Creamery Company, founded in 1921, appears all that would be in this building. However, it shared the same building as the Tulip Hall. The Tulip Hall, located on the second floor, was known during the 1920s as a secret meeting place for KKK members every Tuesday evening.

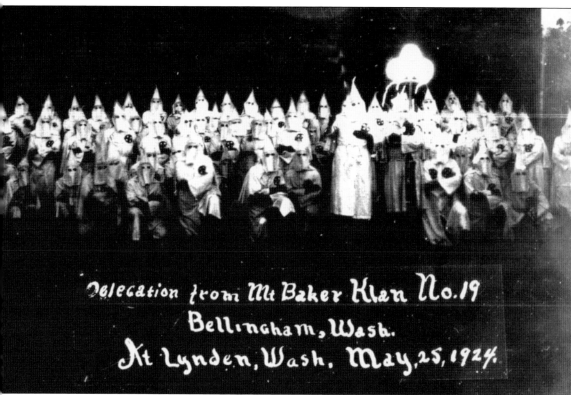

Delegation from Mt Baker Klan No.19
Bellingham, Wash.
At Lynden, Wash, May 25, 1924.

It is a common view that in the 1920–1930s, the Bellingham Chapter of the KKK was one of the strongest and longest lasting in Washington. Primarily against immigration, minorities, and Catholicism, they protested and had white power marches and events throughout the community. Before the pro-Hitler Silver Legion, the Klan in the area had immense political influence, though J.J. Donovan, a huge figure in the business side of events, was Catholic and put a stop to many of the things that they wanted to do. One little known fact about this image in particular is that the list of names of these Klan members is missing.

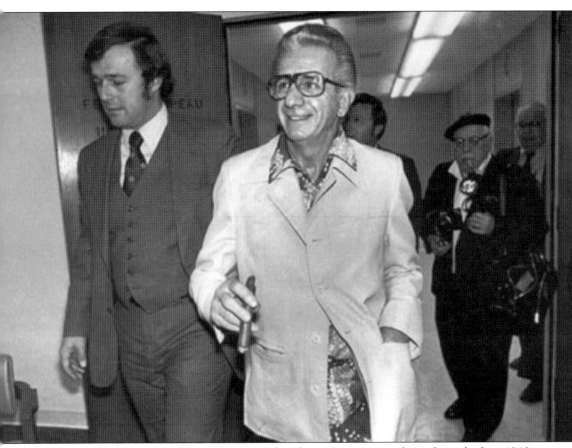

Jimmy "the Weasel" Fratianno was an Italian-born American mobster from the late 1940s to 1977. Jimmy worked primarily in Cleveland, Ohio, until he moved to Los Angeles, California, and became the crime boss for the city. Jimmy openly admitted to killing people, stating that he did not regret it because the people he killed were not innocents—they were generally other people active in the criminal world. After ratting out many individuals, including one that was attempting to get him killed, he was admitted into the witness protection program. Once in witness protection, he was moved to Bellingham, where he stayed for the majority of his time in the program. At the time, he was the highest-ranked mobster to give information to the FBI. (Author's collection.)

James Kinney was a Bellingham resident who suffered from mental illness. The unfortunate victim that led to his arrest was Keri Lynn Sherlock, who was visiting her uncle. Last seen on October 3, 1998, her body was found on Mount Baker Highway. Following the evidence and a tip from *America's Most Wanted*, Kinney was arrested and also charged for two other murders. (Author's collection.)

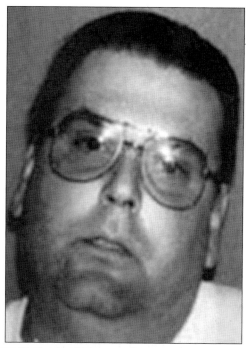

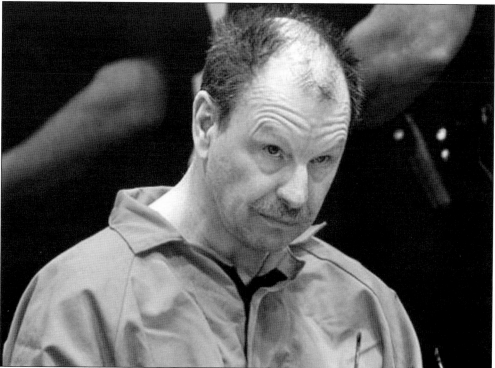

Gary Ridgway, commonly known as the "Green River Killer," is one of the most notorious serial killers in US history, admitting to as many as 90 killings. After leaving the military he found work as a car painter in a truck factory located in Bellingham. One of the murders he was suspected of was that of Rose Marie Kurran, born in Bellingham. (Author's collection.)

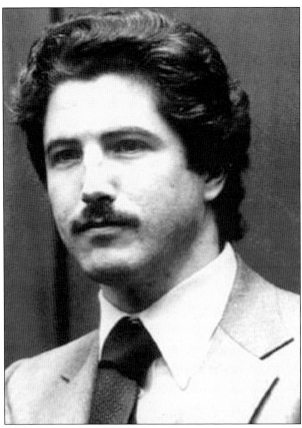

Known together as "the Hillside Strangler," Angelo Buono and Kenneth Bianchi killed 10 women before Bianchi went on the run in 1978, ending up here in Bellingham. Bianchi had a girlfriend and son and even got a job as a security officer to seem normal. Working at Fred Meyer Jewelers, Bianchi eventually convinced two young women who were students at Western Washington University and fellow employees, Karen Mandic and Diane Wilder, to house-sit for him. Once in his house, Bianchi raped and strangled both young women. Police chief Terry Mangan realized the connection and arrested Bianchi. To avoid the death sentence, Bianchi gave up his cousin's involvement and is serving a life sentence at Washington State Penitentiary. Buono died in prison due to an alleged heart attack. (Both, author's collection.)

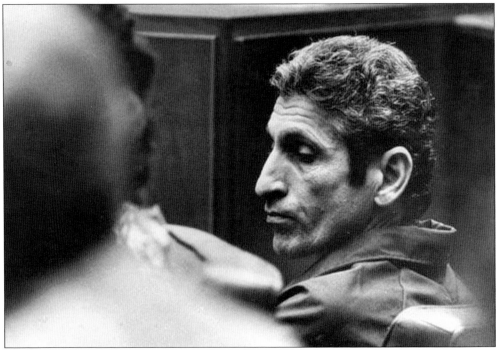

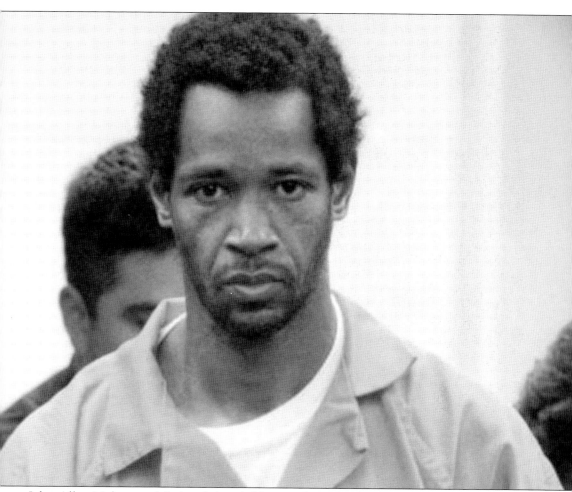

John Allen Muhammad fled with his children to Antigua after his then ex-wife filed for a restraining order. While there, he met and became partners with Lee Boyd Malvo before coming to Bellingham. Civil deputy Mick Jolly and police took his children into custody. In response, John and his partner went to the Washington, DC, area and shot and killed 10 victims to make it appear the killing of his ex-wife was random. After being caught, Muhammad was sentenced to death on November 10, 2009. (Author's collection.)

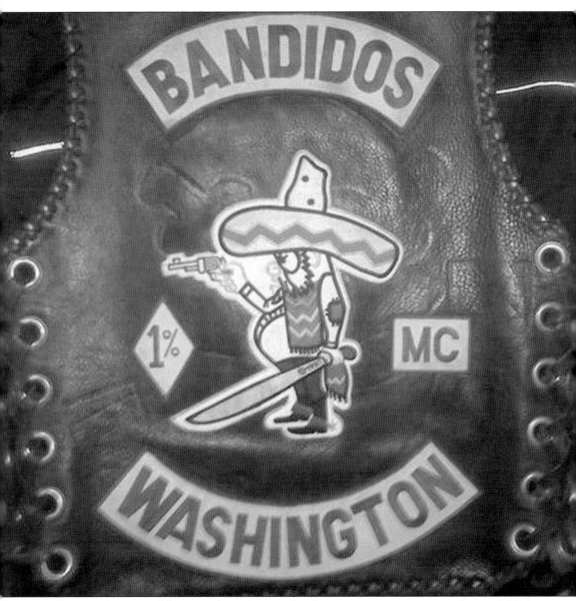

Being such a peaceful city, with its shops and welcoming community, its understandable how so many were not aware of the connection Bellingham, Washington, has with the Bandidos Motorcycle Club. This changed in October 2006 when police arrested George Wegers, a member of the Bandido Nation. However, George Wegers was not just any member—he was the international president of the whole Bandido Nation. A month after his arrest, police arrested over 30 other members on charges such as conspiracy, witness tampering, and various drug and gun violations. (Author's collection.)

Seven

A Toast to the Future

What better way to honor both the past and inspire the future than by taking a look at photographs of Bellingham, both then and now, side-by-side? In this chapter, the reader will see the essence and structure of this city known for its subdued excitement progress and shape into what has continued to be a home to so many. Here is to Bellingham, a picturesque city that has not only endured the hard times with fervor, but also has quietly grown into a culturally rich destination enjoyed by both adventurers and romantics alike. May Bellingham continue to be one of Washington's best-kept secrets.

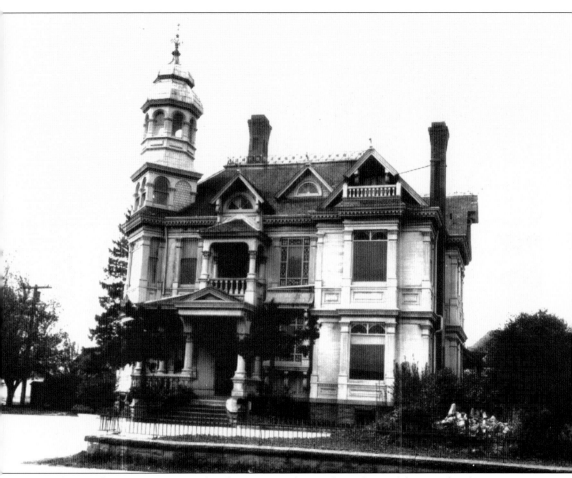

The Roeder House was completed in 1897 and served as a beautiful example of Victorian-era architecture. Though Henry Roeder never lived in the home, his wife, Elizabeth, did with their daughter Charlotte "Lottie" Roeder-Roth and Lottie's husband Charles Roth. Unfortunately, the home was torn down in 1956, despite its considerable historical value.

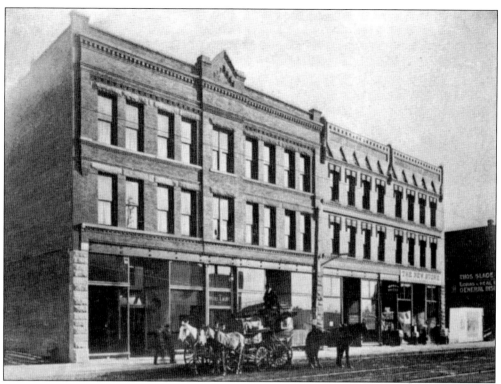

Built in 1903, Hotel Laube is over 100 years old and one of the last surviving buildings from its time period in downtown Bellingham. It was the first of many commercial buildings constructed that made up Bellingham's central business district and considered the most modern hotel in New Whatcom. It began as a hotel for 75 years, hosting a restaurant on its first floor. Currently, the Laube is used for apartments on its upper floors and businesses on the first. Hotel Laube's brick structure is a perfect representation of the architecture of its time. (Below, author's collection.)

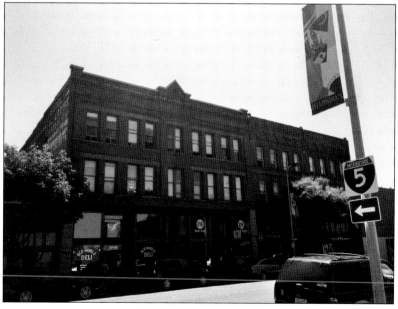

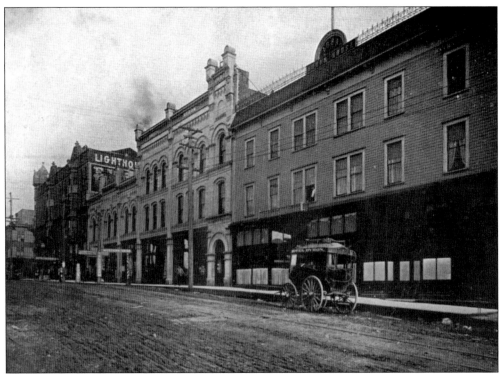

The Byron Hotel was built in 1889 and named after its owner, Capt. H.C. Byron. However, Captain Byron sold the hotel in 1910 to Leopold F. Schmidt, who remained the owner until his death in 1914. To commemorate him, his investors renamed the edifice the Leopold Hotel. In the 1980s, the Leopold Hotel underwent renovations and was converted into a retirement living community and was added to the National Register of Historic Places in February 1982. (Below, courtesy of J.J. Johnson.)

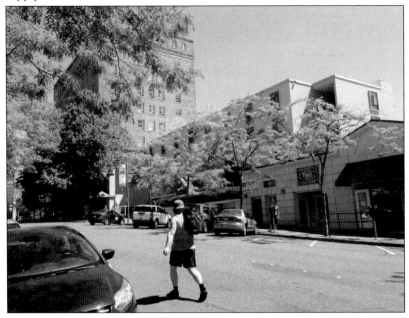

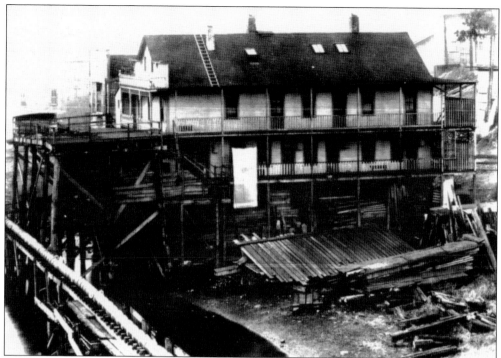

Early in the 20th century, Whatcom Creek's channel was dredged, and the terminal building (later to be called Citizen's Dock) was built on pilings. Close to the heart of old town Bellingham, it became a part of what was considered Bellingham's front door. The C Street viaduct ran from the bluff on Dupont Street all the way down toward Holly Street and Roeder Avenue. Presently, this runs through what is now Maritime Heritage Park, where a fish hatchery has taken the place of where the top of the viaduct once stood. (Both, author's collection.)

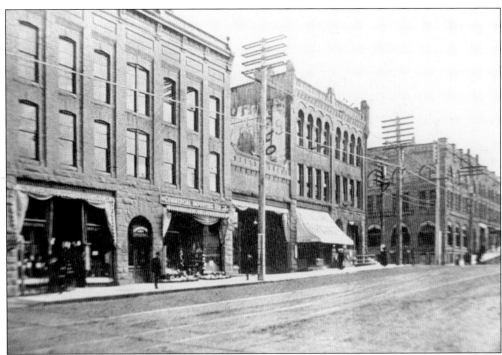

Commercial Imported Tea was open from 1903 to 1907 and located in what is still to this day the thriving business district in downtown Bellingham. Just coming out of an economic rise and bust caused by finding out that it would not be used as the rail terminus, businesses were at high risk for failure. The image above was taken from Railroad Avenue looking east down State Street toward Holly Street and would have been taken shortly after Fairhaven and Whatcom had merged into Bellingham. Pictured center is where Liberty Theater would later be located. (Below, author's collection.)

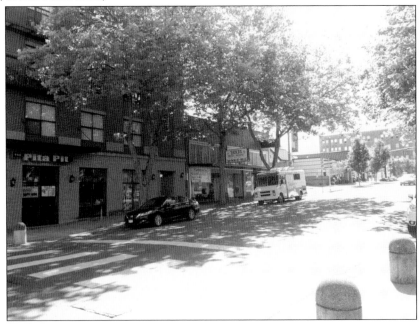

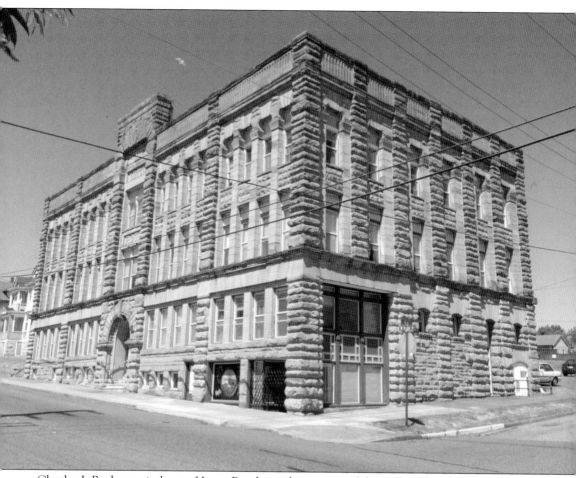

Charles I. Roth, son-in-law to Henry Roeder and co-owner of the Bellingham Bay Quarry, was so impressed by the round-arched and sandstone-faced designs by Elmer H. Fisher, he wanted to showcase his sandstone quarry product in this Richardsonian Romanesque–influenced style with a building of his own in Bellingham. He had a building constructed in 1890 named the Lottie Roth Block after his wife. The south and east exterior walls were constructed of Chuckanut sandstone, and the north and west walls were made of brick. Since its construction, it has been home to a bank, the Chuckanut Hotel, and even the *Imperial City News* briefly.

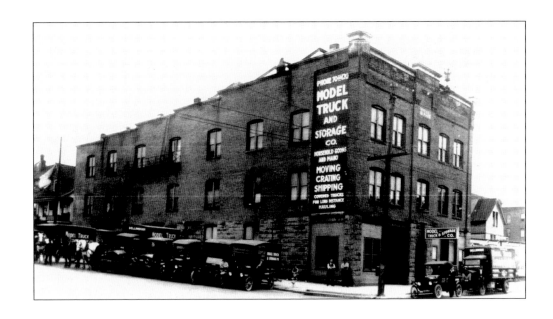

The Model Truck and Storage Co. was incorporated in 1918. It was located at 1328–1330 Elk Street, now State Street, in Bellingham. In its time, it was one of the leading transfer companies in the area. An outdoor Bavarian-style beer garden called Schweinhaus Biergarten, known for serving great beer and German dishes, is located there today. (Below, courtesy of J.J. Johnson.)

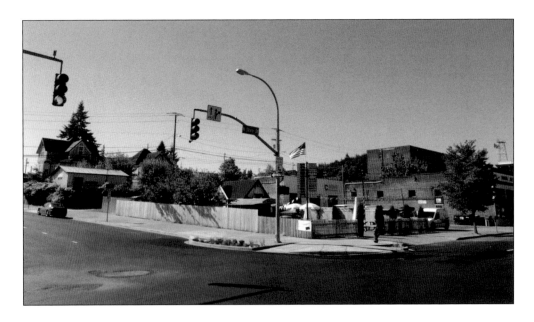

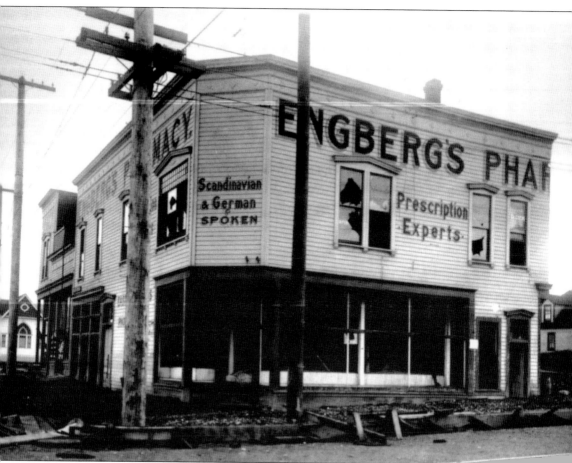

H.C. Engberg founded the Engberg Pharmacy in Bellingham in 1890. The store was originally located in Fairhaven and then moved to the southwest corner of Holly Street and State Street into a building owned by Charles Roehl. In 1908, plans to tear down the building seen here and replace it with a new one called the Alaska Block were implemented.

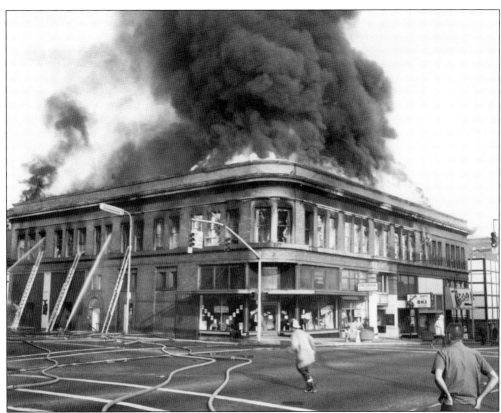

On the southwest corner of State and Holly Streets rests an investment service company, but this site used to be the location of the Alaska Block. When owner Charles Roehl announced its construction, it was said that it would make Bellingham a "first class city." On June 14, 1969, one of the biggest fires in downtown Bellingham's history consumed the Alaska Block, taking two lives as well as eight other businesses. Local fireman had been concerned that another fire station was necessary to help with response time, and soon after, Bellingham established an additional station. Over time, there was complacency toward Bellingham's historical buildings, and as a result, very few are still left. (Below, author's collection.)

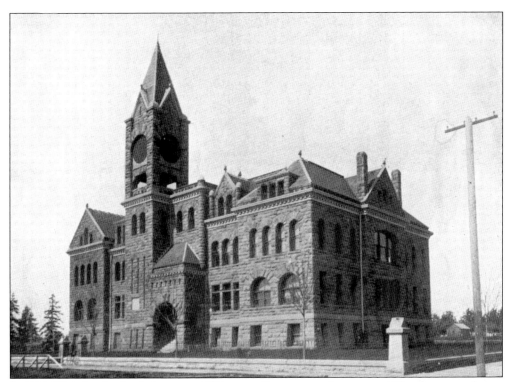

In 1890, W.A. Ritchie built the second Whatcom County courthouse out of Chuckanut sandstone from local quarries. The structure cost $65,000 to construct, and once finished, it towered over its surroundings. The courthouse took up the lot of land that fell between H, Ellsworth, G, and Farragut Streets. The courthouse was eventually purchased by Peter Berg Peterson in 1953, who decided to tear it down. Currently, the space that once housed the grand building is now the home to Fouts Park in a quiet neighborhood, sporting a play set for local children. (Below, author's collection.)

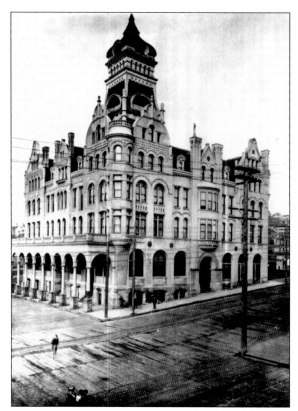

The majestic Fairhaven Hotel was built in 1890 by the Fairhaven Land Company. Its construction cost $150,000 and featured every architectural style known to the designer. The company spent just as much on the furnishings, and the Fairhaven Hotel was known in the time as one of the grandest hotels of the Puget Sound. In 1895, Mark Twain stayed there and was quoted saying that the Fairhaven Hotel was "the grandest hotel west of the Mississippi and north of San Francisco." To the left, one can see how the hotel was surrounded by wood-planked roads during its prime. Currently, the property's old site, as shown below, is not in use. (Both, author's collection.)

In this view looking down Harris Avenue in the heart of Fairhaven, one can see the grandeur of the famous Fairhaven Hotel to the left dominating the image, with tracks for the trolley running down the center of the road. Today, those tracks have been filled in, but some of the bricks are still there. Toward the middle is the intersection with Twelfth Street and a grocery store using the space in which the Fairhaven Pharmacy is located now. The Fairhaven District of Bellingham prides itself on preserving its history, learning from the loss of so many great structures to fires and complacency. (Below, author's collection.)

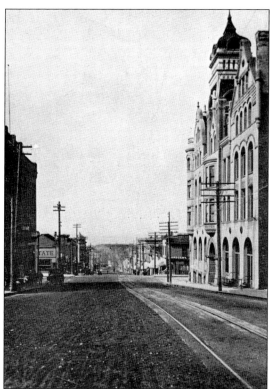

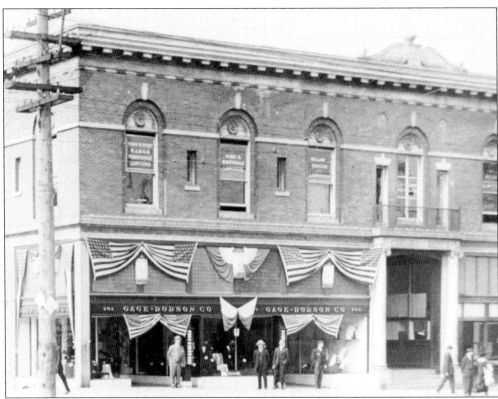

Gage-Dodson was a clothing company downtown original established as Gage Clothing Company by George Gage in 1891. Later, his company was consolidated with McDougal & Dodson Clothing Company of Fairhaven and, through a series of name changes, landed on Gage-Dodson. It was known as the place to go to buy suits as well as other formal wear. Gage-Dodson stayed open all the way up into the 1950s, and currently, it is the home of Belle Bridal and Formal Shoppe, a business that complements the legacy of one of Bellingham's pioneer businesses. (Below, author's collection.)

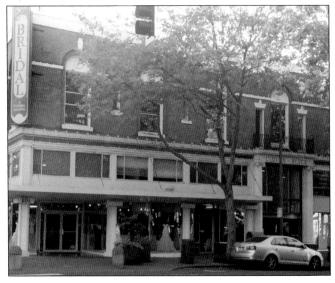

The Diehl Motor Co. legacy started in 1907 when Hugh Diehl and his partner Charlie Simpson took over a Ford dealership from Charles Stanbra. Later on, Diehl bought out Simpson's interest in the company, and four generations of owners later, the business is still in the family. Over the years, the dealership has survived two world wars, the Great Depression, flooding, and arson. The dealership was located at 1500 Cornwall Avenue, right on the corner of Champion Street. Below is a photograph of the dealership before the fire in the early 1940s, and above is the replacement building, currently occupied by Washington Federal. (Above, courtesy of J.J. Johnson.)

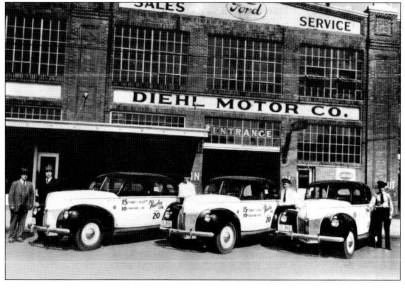

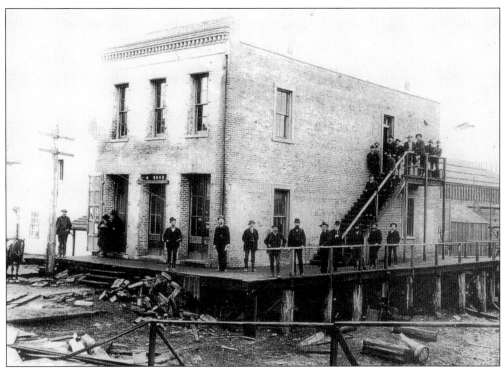

The Washington Territorial Courthouse, located at 1308 E Street, was built in 1858, making it the oldest brick building in the state of Washington. It was built with bricks from Philadelphia, Pennsylvania, that, due to no dependable cross-country transportation at the time that far northwest, was shipped around Cape Horn and up the West Coast. The building was erected in response to the Fraser River gold rush to be used as a store, commission house, and bank. Later, it became the territorial courthouse for Whatcom, Skagit, San Juan, and the island counties in 1863. Since then, it served as Whatcom County courthouse up until 1891. (Below, author's collection.)

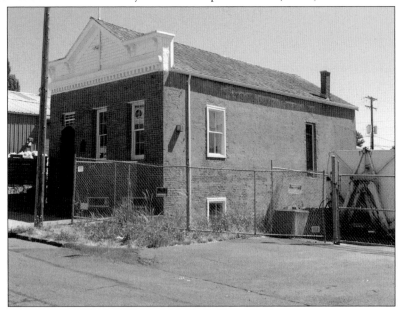

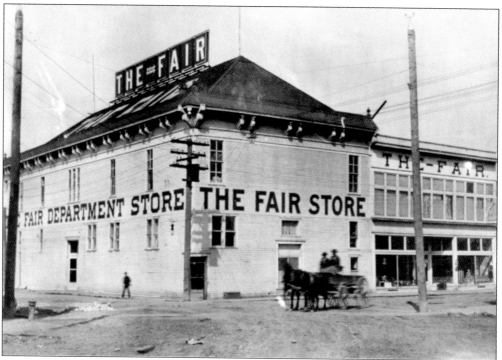

The Fair Store was a large supply store that sat behind the Flatiron Building and was a main stop for many of the locals for grocery, household, and everyday supplies that they might need. In the foreground, one can see what used to be the city's courthouse, now the home to Whatcom Museum. (Below, courtesy of J.J. Johnson.)

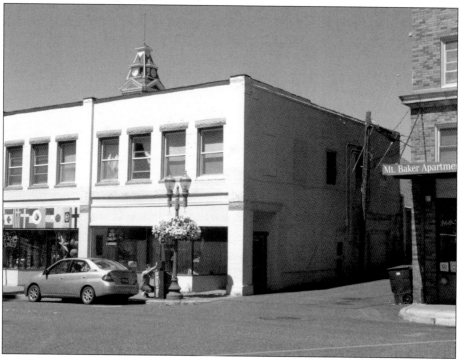

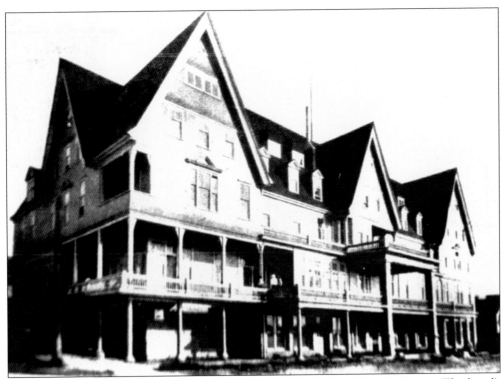

Built in 1910, Hotel Baker was located on the corner of Holly and Forest Streets. The hotel's grandeur once made it a Bellingham landmark, and it graced the front of numerous Bellingham postcards. Once it was closed as a hotel, it was used as one of the locations for St. Luke's Hospital as well as a storage for a bus company to park their buses. Below, Whatcom Food Co-op is utilizing the space now. (Below, courtesy of J.J. Johnson.)

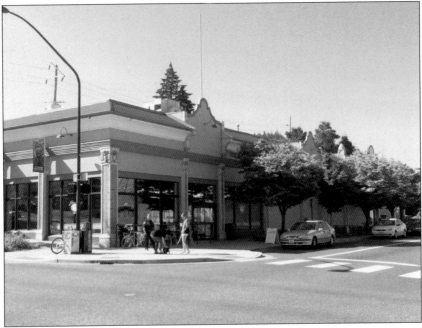

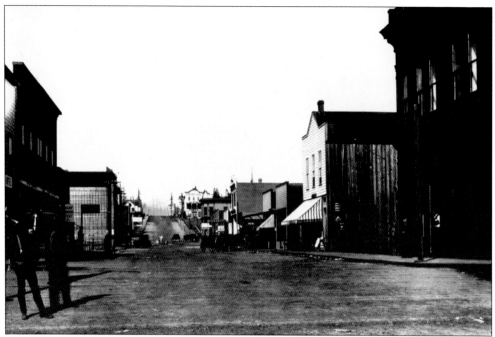

Pictured here is the same view up D Street from the railroad access at the intersection with West Holly Street. This road, which was once covered in wood planks and served as the home to so many shops and businesses, has become industrial space. (Both, author's collection.)

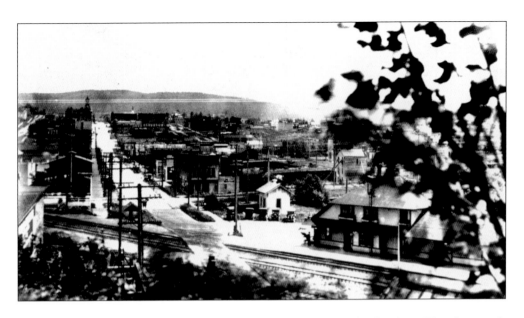

Pictured here is a view of the train station in the Fairhaven district of Bellingham. The photograph above was taken from "Dead Man's Point," so named because it used to be a graveyard and an attraction to local ghost hunters. Present-day Dead Man's Point does not exist, as the entire hill has been removed. This change began around World War I to build a shipyard that was once located at the southwest side of where Harris Avenue meets the ocean. (Both, author's collection.)

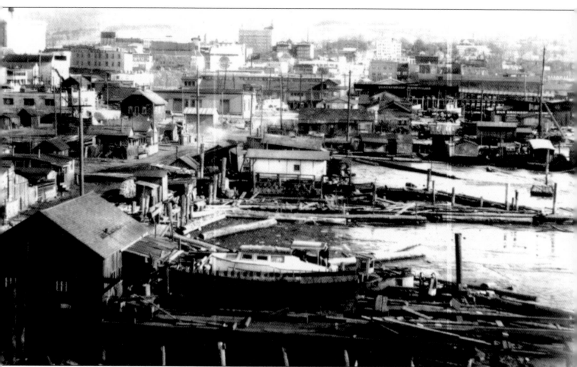

Pictured here is a view of Bellingham from the third story of the Ritz Hotel. The hotel was located on Holly Street, where Whatcom Creek meets the bay. It was one of the least expensive hotels in Bellingham and had a wild reputation. This viewpoint from the Ritz Hotel looks up Holly Street hill toward the better part of town.

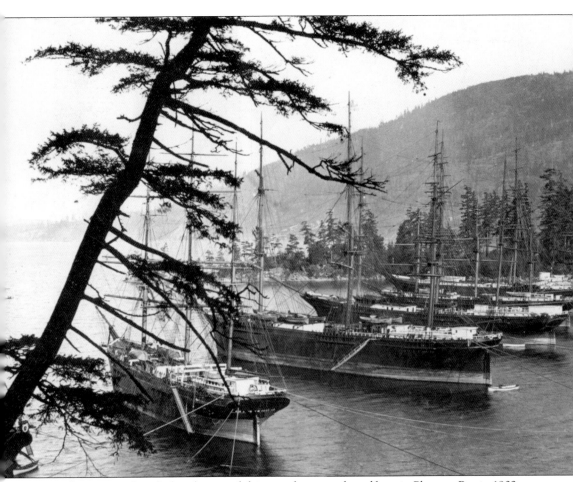

At least six unidentified triple-masted ships are shown anchored here in Pleasant Bay in 1902, most likely owned by the Pacific Packing Company that worked with Pacific American Fisheries. These ships used to bring both men and supplies to and from PAF's canneries, a business that supplied employment for those locals here in Bellingham all the way into the far north of Alaska. -
Just north of Larrabee State Park, Pleasant Bay is enjoyed by many for its beachfront properties as well as a public boat access to the bay. Even after over 100 years, the differences in the bay are so minimal, it looks much the same as it did back when these six massive ships were anchored here. Attracting locals and tourists alike, the view of the San Juan Islands and the allure of this bay's serene qualities confirm that naming it Pleasant Bay only seemed natural.

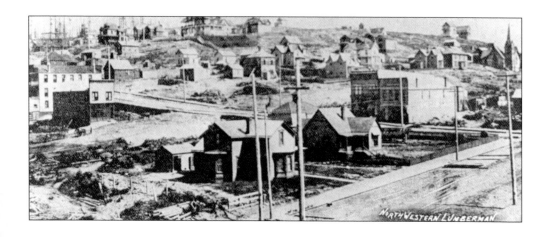

A rare glance into what life was like in Fairhaven just prior to the revitalization conducted by the Fairhaven Land Company, this was an image taken in 1890 by a local newspaper called the *Northwestern Lumberman*. Before Nelson Bennett came to Fairhaven with his partners, it was said that there were as few as 50 people living in Fairhaven, and the only dependable mode of transportation was by rowboat. In both images, the Wardner Castle is visible in the background. The road in the front is Harris Avenue, with Fourteenth Street visible leading up the hill. This part of town was known as both Nob Hill and Knox Hill. (Below, author's collection.)

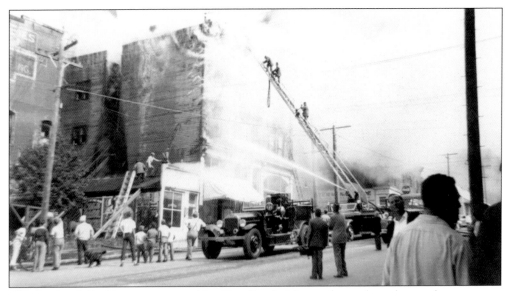

The Sandwick Building, constructed by Otto Sandwick, was located on the northwest corner of Eleventh Street and Harris Avenue in the Fairhaven district of Bellingham. It was the home of Citizens National Bank of Fairhaven as well as other shops, such as Sandwick Candies. Unfortunately, on September 10, 1949, the building caught fire, and despite the firefighters best efforts, it burned down. Afterwards, it became the location of A Lot of Flowers before construction went underway for the Rocket Building. Currently, Fat Pies and Rocket Donuts are located there. (Below, courtesy of the author.)

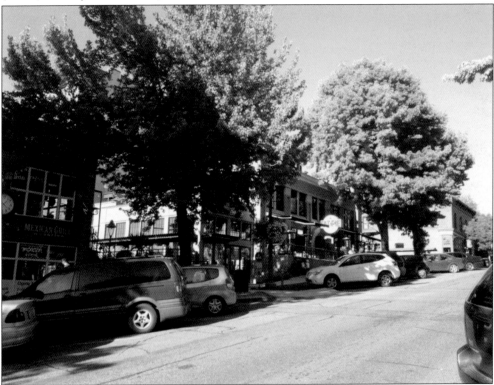

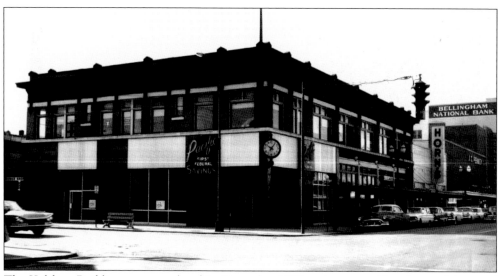

The Kulshan Building was completed in December 1923 and was considered an architectural triumph. Designed by Frank C. Burnson, it is located on the southeast corner of Magnolia Street and Cornwall Avenue. At its completion, every room was already leased out. In 1956, Pacific First Federal and Loan Co., seen above, took out a 50-year lease with the option to buy the building. The building would not survive the 50 years and was torn down in April 1993 to construct a branch of Washington Mutual, which acquired Pacific First Federal, in its place. Currently, a branch of Chase Bank can be seen at its location, after it was acquired Washington Mutual. (Below, courtesy of J.J. Johnson.)

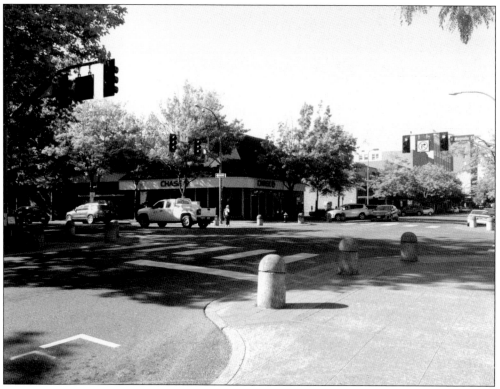

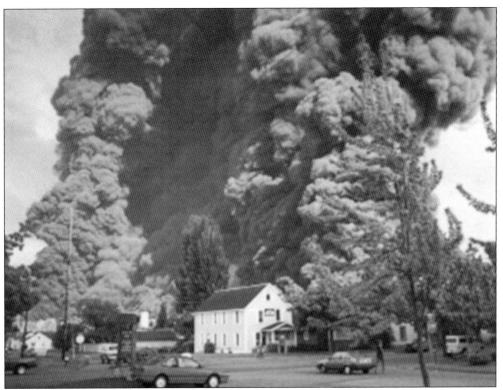

A 30,000-foot-tall cloud of black smoke billows from Whatcom Creek, dwarfing the landscape surrounding it. On June 10, 1999, a ruptured gasoline pipeline dumped 277,000 gallons of gasoline into Whatcom Falls, and it was somehow ignited. The explosion was reported to be visible from as far away as the city of Vancouver, and as the gasoline ignited like a fireball down Whatcom Creek, it turned it into a river of fire. Two 10-year-old boys died from burn injuries, and a teenager died after passing out from the fumes and drowning in the creek where he was fly-fishing. One of the boys, Wade King, had a school named after him, and the fault of the accident was found to be that of Olympic Pipeline, who settled in court for $112 million. (Below, author's collection.)

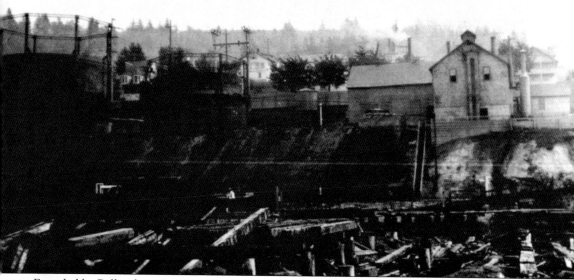

Founded by Bellingham Bay Gas Co. in the 1890s, this gas plant operated into the 1960s before it was bought by residential developers. In 1975, most of the property was purchased by the City of Bellingham and turned into what is now Boulevard Park, located on South State Street. In fact, the second holding tank is now a lookout point.

The Terminal Building was erected in 1888, making it the oldest structure in the Fairhaven district. The reason it is called the terminal building is thought to be one of two reasons. One is that during the same year of its construction, the Bellingham Bay Railway and Navigation Company as well as the Bellingham Bay & British Columbia Railroad Company lead by Pierre Barlow Cornwall pushed to connect Bellingham with rest of the nation's rail system, and it was hoped that Fairhaven would be chosen as the western headquarters and terminus of the Great Northern. The second reason is that the 1930s owner wished to have his buildings associated with the end of the trolley's route, which ended at its crossroads. (Below, courtesy of J.J. Johnson.)

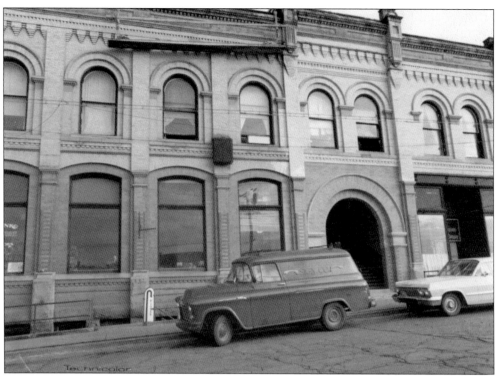

The Nelson Block, which rests at the southeast corner of Harris Avenue and Eleventh Street in the Fairhaven district, was built by J.P. Nelson in 1900. It was constructed to house a banking establishment. The building was designed in a High Victorian Italianate style and utilized sandstone from the local Chuckanut quarry to trim its exterior. The Nelson Block was the home for a bank until the Great Depression, and since then, it has been the home to many businesses. (Below, courtesy of J.J. Johnson.)

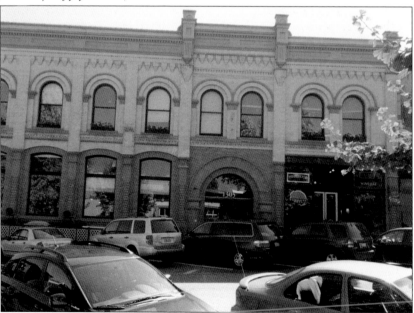

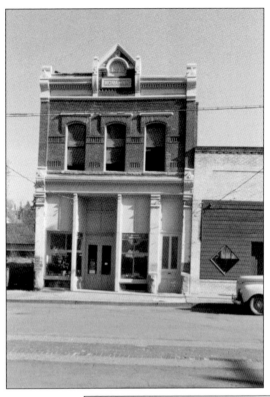

Thomas E. Monahan used to have a saloon, the Board of Trade, along the main wagon trail that out-of-town visitors used to come into Fairhaven. Later, he decided to erect his own building, and for $7,000, the Monahan Building, named after its owner, was completed in 1890. Using a High Victorian Italianate style common in Fairhaven at the time, it became the home to Monahan's new saloon, the New Board of Trade. Priding himself with running a respectable establishment, customers were able to enjoy fine wines, liquors, and cigars. Presently, it is the home of Fairhaven Runners, one of the district's well-known and established businesses. (Below, courtesy of J.J. Johnson.)

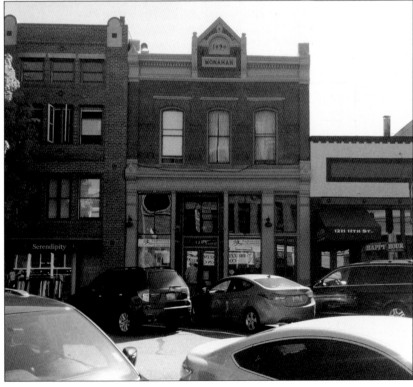

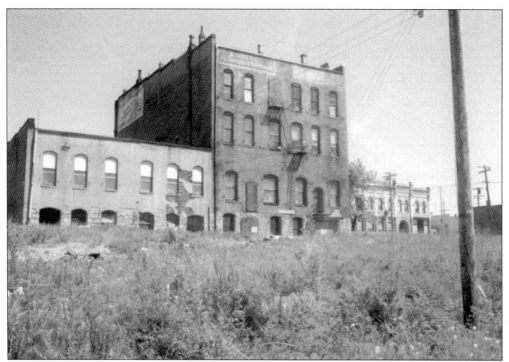

The Knights of Pythias and Masonic Hall, built in 1893, has been the meeting place for many societies and fraternal orders named on the central bay's sheet metal escutcheons. Boasting a Richardsonian Romanesque–style construct, it has housed a wide variety of businesses as well as a school of industries on its upper floors. One of the greatest aspects of the rehabilitation of the Fairhaven district, started by the Imus family in the 1970s, is that of the Village Green, as seen here. Its stage has attracted tourists for a variety of events, and in the summers, one can watch movies played on the outdoor screen. A known landmark of Fairhaven, the Village Green also hosts a mural to commemorate members of the community. (Below, courtesy of J.J. Johnson.)

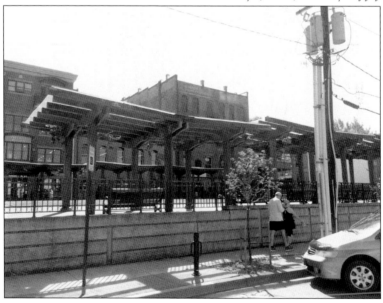

DISCOVER THOUSANDS OF LOCAL HISTORY BOOKS FEATURING MILLIONS OF VINTAGE IMAGES

Arcadia Publishing, the leading local history publisher in the United States, is committed to making history accessible and meaningful through publishing books that celebrate and preserve the heritage of America's people and places.

Find more books like this at
www.arcadiapublishing.com

Search for your hometown history, your old stomping grounds, and even your favorite sports team.

Consistent with our mission to preserve history on a local level, this book was printed in South Carolina on American-made paper and manufactured entirely in the United States. Products carrying the accredited Forest Stewardship Council (FSC) label are printed on 100 percent FSC-certified paper.

MADE IN THE USA